FOREVER HOME

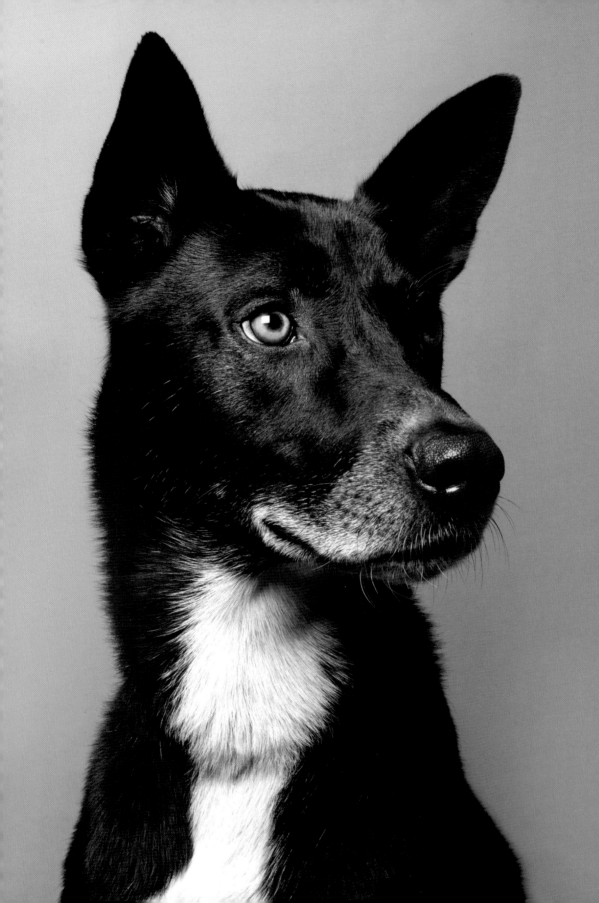

FOREVER HOME

THE INSPIRING TALES OF RESCUE DOGS

Traer Scott

PRINCETON ARCHITECTURAL PRESS · NEW YORK

Contents

To all of the dogs I have loved and lost

I want to tell you my dog Rosie's story: she was born on a local farm and has been loved every day of her life. Pretty boring as far as stories go, right? Rosie is amazing and she loves just as deeply as any dog. She is a happy example of a dog who has never had a bad day in her life. But most dogs aren't so lucky. This book focuses on some of those dogs.

Why do we love to tell these stories of heartbreak and second chances? I believe that it's because they continue to remind us of the resilience of dogs, of their ability to love despite abuse, abandonment, and betrayal. In short, these stories educate and inspire us to do better. I have told the stories of many animals in my books over the years, but I usually let the images do most of the talking. This time I needed more words because these are not just the stories of individual dogs; taken collectively these tales form a snapshot of the greatest challenges in animal welfare right now.

I want this to be a book of truths, but also of contradictions, because I believe that is the only way we might glimpse the whole truth:

The fact that sometimes a forever home is not forever; that every home is a step toward a forever home.

That adoption is not always easy; that it's almost always worth it.

That the story doesn't end when a dog leaves the shelter; that if a dog doesn't leave the shelter, its story ends.

That sometimes one dog needs an entire village to save it; that there will simply never be enough villages to help all of the dogs in need.

That calling a place a KILL shelter just vilifies people who are left to deal with other people's mistakes; that NO KILL is also problematic.

That posting comments on social media about how awful someone is for surrendering their dog does nothing to help the dog; that social media is a very powerful tool in rescue.

That no matter what you call it, buying a puppy from a pet store is not "rescuing it"; that no matter what you have been told, buying a puppy from a responsible breeder is not evil.

That making people jump through endless hoops to adopt is self-sabotage; that handing a dog over to just anyone is a massive betrayal of custodial trust.

That one of the most powerful resources to help save lives are foster homes; that one of the hardest things to find is a willing foster home.

That shelters in some parts of the country are empty; that shelters in other parts of the country are bursting.

That the dog you think you want is often not the dog you need; that the dog you need is waiting for you to want it.

Basically, it's complicated—but the stories of the dogs in the following pages navigate a path through these muddy waters. Let's listen.

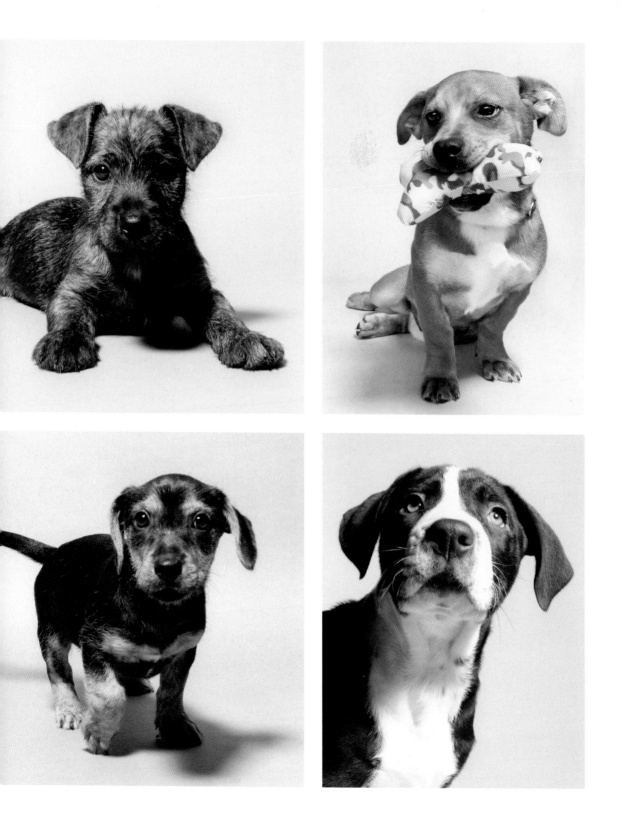

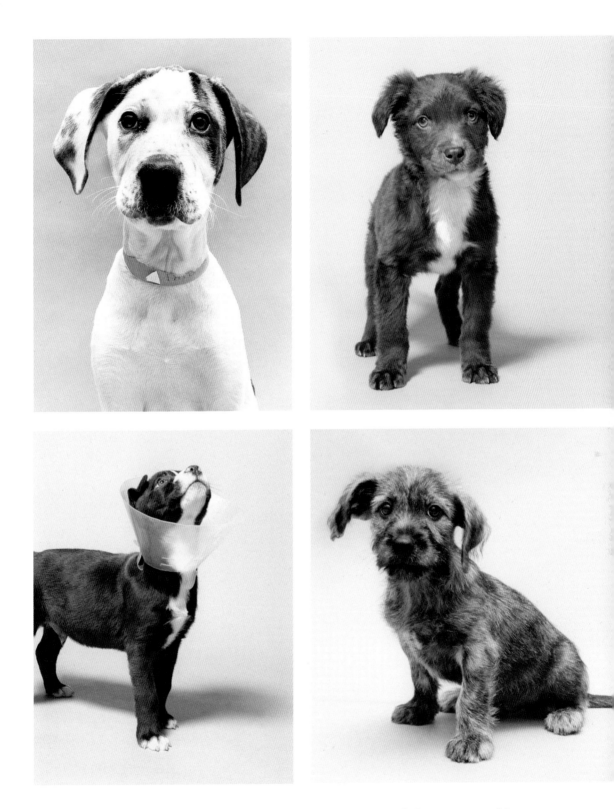

Thousands of puppies are transferred every week from high-volume shelters to areas of the country with few adoptable dogs. For these littles, their stories are just beginning.

THE STORIES

BEAN

two-year-old female cockapoo

Bean (originally Rosemary) was bred in a puppy mill and at about ten weeks old was trampled by a horse on the farm. The incident left her with a broken leg. The mill owners brought her to a vet, which is very unusual, but when they learned how much it would cost to fix her leg, the farmer abandoned her at the vet's office. The vet contacted a local puppy mill rescue that agreed to pay for her surgery. A family who lived near the surgeon's office agreed to foster her throughout her recovery and rehabilitation.

After the leg surgery was completed and paid for by the rescue, the puppy mill owner asked if they could have her back so they could sell her. The rescue refused. The farmer also wanted the crate that they had left her in at the vet returned to him.

Rosemary's foster family had recently lost their eldest dog and were excited to have a puppy in the house to distract from the grief. However, Rosemary was not an easy puppy. She was extremely active and rambunctious, and she barked and nipped relentlessly. Soon after she finished treatment for her leg, her foster family went on vacation and their dog sitter nicknamed her "the devil dog."

When the family returned, they found that Rosemary had noticeably calmed down. She was still wild but was finally starting to show her sweet, quiet side. They decided to adopt Rosemary as an antidote to their recent grief and renamed her Bean after a beloved character in the sci-fi novel Ender's Game by Orson Scott Card. She is still a mix of crazy and sweet, but she brings endless joy and amusement to her now forever home.

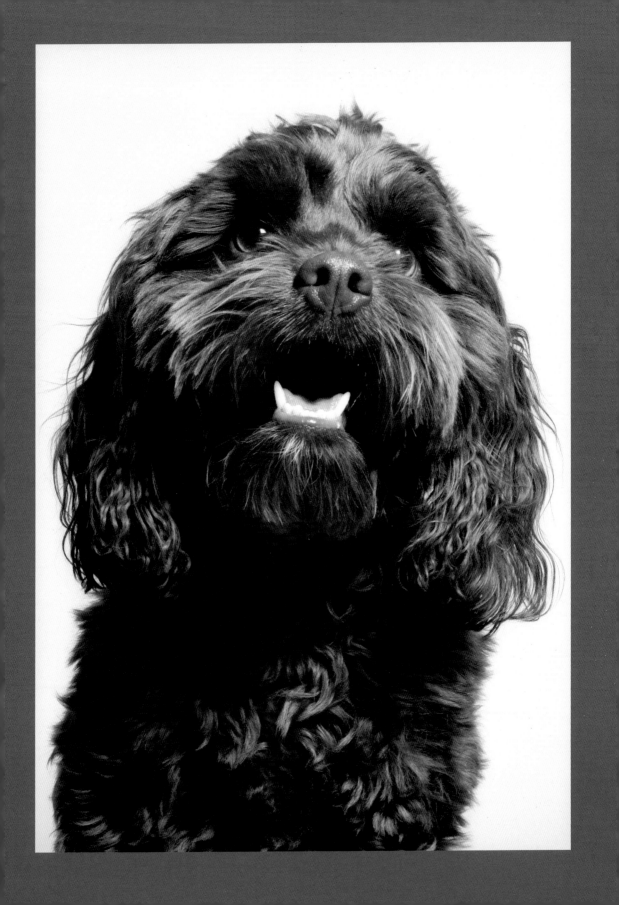

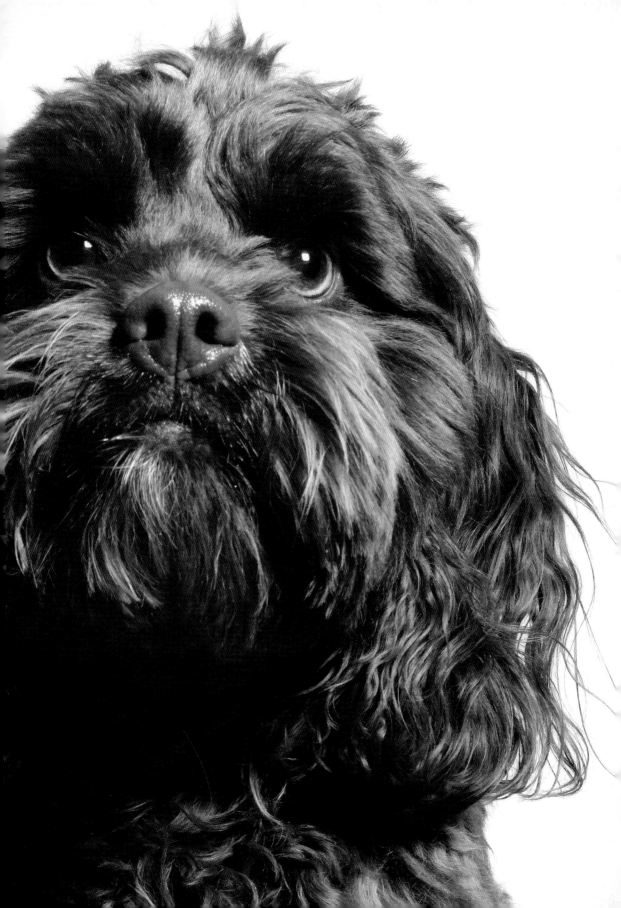

BUSTER

eleven-and-a-half-year-old male mixed breed

Buster was one of countless animals who suffered along with their people during Covid. He was surrendered to a city shelter in the middle of the pandemic. Buster had belonged to an elderly disabled person who had been quarantining alone with him inside his home for almost a year. Apparently, family members had been dropping off dog food and supplies for them but were never allowed inside the house for fear of transmitting Covid. The family thought that everything was OK, but it wasn't. Buster's owner was sick, and Buster had been neglected to the point that he was emaciated, had a severe limp, and was flea infested. He was wasting away, literally near death, when a family member with power of attorney signed Buster over to the city shelter in January 2021. He was quickly transferred to a private rescue with more resources, where his medical issues could be treated.

Buster gained eight pounds in two weeks, but X-rays revealed old, untreated injuries that had happened when he was a puppy, causing severe osteoarthritis. It was soon discovered that Buster was a lifer in the shelter system. During his exams a microchip was found, indicating that he had in fact been adopted from the same rescue in 2010, after being brought up as a southern transport dog. His history prior to 2010 is unknown, but most of the transports were found as strays before being sent up to New England.

Buster was gentle and kind and would limp around the shelter to say hi to people. Although he was ridiculously sweet and well tempered, the rescue was unsure if they could place him because of his poor health outlook, but after he was stabilized, Buster was adopted out in March 2021 as a "medical/hospice adoption," meaning that the home had full knowledge he would require a lot of medical care and might not have much time left. He still limps but is happy and loved.

CARL

five-week-old male shih tzu/poodle mix

Carl was born in a wire cage in a puppy mill. He was surrendered to a rescue in May 2021 at just four weeks old, after his front leg had been mutilated by an unknown animal while he was still living in the cage he had been born in. The remaining humerus bone had been left exposed for more than two days. When the puppy mill owners finally took Carl to the vet, they wanted to know if the necessary care would cost more than what they could get for selling him. The numbers didn't add up to their liking, and they left him at the vet's office.

After the amputation, Carl healed and adjusted very quickly to having three legs (as dogs often do). He is now a normal, rambunctious puppy who loves running in the yard and playing with toys. A forever home is already waiting for Carl, but he won't officially get there until he is neutered at six months old.

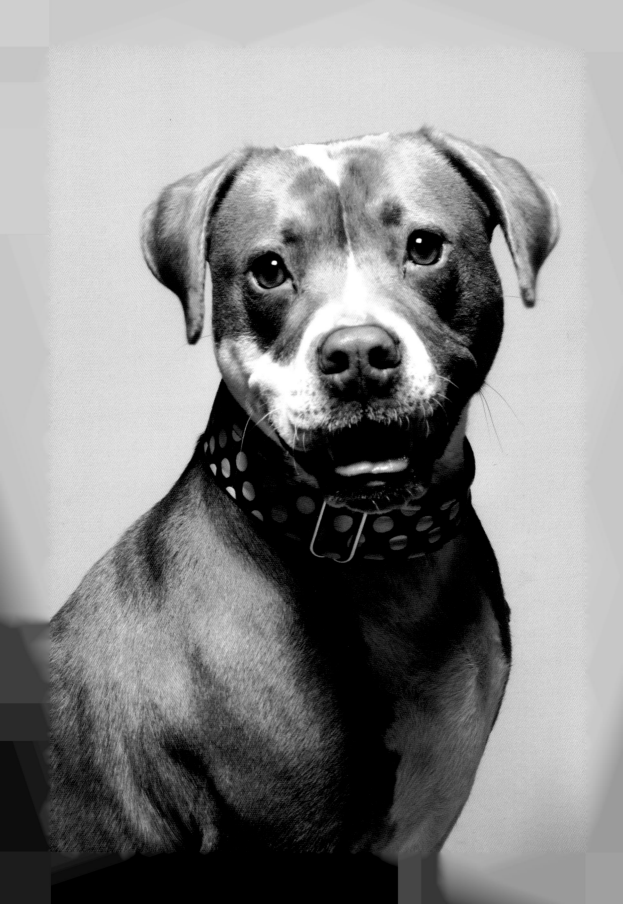

CLOVER
three-year-old female pit bull mix

Clover came to New England as a Southern transport in March 2019 and was adopted out almost immediately. Either due to trauma or lack of socialization, she was terrified of men. At first, the husband in the family couldn't touch her or come near her, but over time she learned to love him.

Clover's new home had another dog, and initially the two did very well together—playing, sleeping, and sharing. At some point they got into a scuffle, which no one thought much about until it happened again. This time it was more intense, so the family took her to the Tufts veterinary clinic, where she was given a behavior evaluation and placed on Prozac, but her aggression toward the family's other dog escalated until it was injured to the point of requiring vet care. The family called the rescue and explained that they wanted to keep Cover but weren't sure what to do.

The rescue's behaviorist investigated and determined that Clover was displaying generalized resource guarding: basically, she was guarding things that meant a lot to her, but not one specific thing. Sometimes it was food, sometimes space, sometimes her owner; her behavior was difficult to predict and even more difficult to fix. She was also exceptionally shy with new people and still terrified of men. The rescue recommended that the family return her before she severely injured their other dog. Clover was returned in October 2020, after which she was emotionally shut down and traumatized. She didn't want to walk, play, or

eat. The shelter adjusted her meds and spent three months working with her on targeted behaviors while also desensitizing her to men. Finally, she was ready to go up for adoption again.

Clover was next adopted out in February 2021 to a very experienced home with no other dogs. The owner lived in a loft with floor-to-ceiling windows. The complex did not allow pit bull-type dogs but had made an exception for Clover on the condition that she was very quiet. Unfortunately, the windows provided her with a clear view of everything: people coming and going, cars, other dogs, etc. Suddenly Clover was living in a veritable fishbowl and there was constant stimulation that caused her to bark incessantly. After only one night she was brought back to the shelter.

Finally, in March 2021, Clover was adopted out to a husband and wife with a big house in a rural area. The woman works with behaviorally challenged children and had infinite patience for a dog who needed a little extra understanding. Clover warmed up to the husband quickly and seemed to enjoy the country.

When Clover's first adopter called the shelter to check in on Clover, they connected her with the current adopter. The two women formed a friendship. Clover has finally found the perfect life, which includes people from her past and present. She clearly loves her owners as much as they love her: during the day she gathers their socks and shoes and sleeps cuddled up with the items while they are at work.

COSETTE

two-year-old female boxer

Cosette was raised to be a breeding female at an Amish puppy mill but turned out to be barren, and therefore of no use to the mill owner. When she arrived at the puppy mill rescue, she had a very large cherry eye and some signs of skin disease. The vet determined that the eyeball was completely shrunken underneath the cherry eye and had to be removed.

Cosette's foster family was experienced with puppy mill dogs, but they had never fostered or owned a large dog before and were nervous about what to expect. After they pulled the car into the driveway, Cosette eagerly jumped out and then froze. Many rescue dogs with traumatic pasts have physical coping mechanisms that help them deal with fear, and hers was to sit and refuse to move.

Moving an eighty-pound dog who doesn't want to move is not easy, and once they got her *inside*, Cosette refused to go *outside* to use the bathroom. When she would freeze in place, they would help her walk through the house by moving one single paw at a time. Once outside, she would often walk to the farthest corner of the yard, lie down, and refuse to come back in. The first few days were very difficult: they had to repeatedly carry all eighty pounds of her back into the house. But despite being paralyzed with fear, Cosette never showed any aggression.

Many puppy mill dogs feel safest inside a crate, as that is often where they have lived their entire lives. That first night, Cosette's foster family set her up with a supersized crate and she was able to sleep in it. The second night, however, she refused to go into the crate, so they set up a blanket and bed in the kitchen and that became Cosette's "spot."

Dogs are individuals, and every dog responds and adapts to a new home or environment in different and sometimes unanticipated ways. Cosette was very food motivated, and wagging her cropped tail at mealtime was one of the first signs of happiness she showed. As she became more comfortable and learned from the other dogs in the house, Cosette started displaying other "happy" behaviors like being excited to see her people in the morning and even approaching them to be petted. She had finally learned the standard routine of going outside to use the bathroom and coming back inside afterward, but a few months in she started refusing to come back inside again. When the family would walk into the yard to encourage her to return indoors, she would run away. At first, they assumed that Cosette was running from them in fear and their hearts fell, but soon they noticed that her tail was up and wagging. She wanted to play! Her foster mom started chasing her around the yard and then changing direction to let Cosette chase her. This was the first time in Cosette's life that she had been allowed—and allowed herself— to play.

Eventually Cosette became comfortable enough with her foster family that they realized she was ready to be adopted. Like most puppy mill rescues, she would need a patient family who would let her set the terms and speed of her healing. Cosette showed a preference for men, a rarity among puppy mill rescues, and found her forever home with a couple who had experience with boxers.

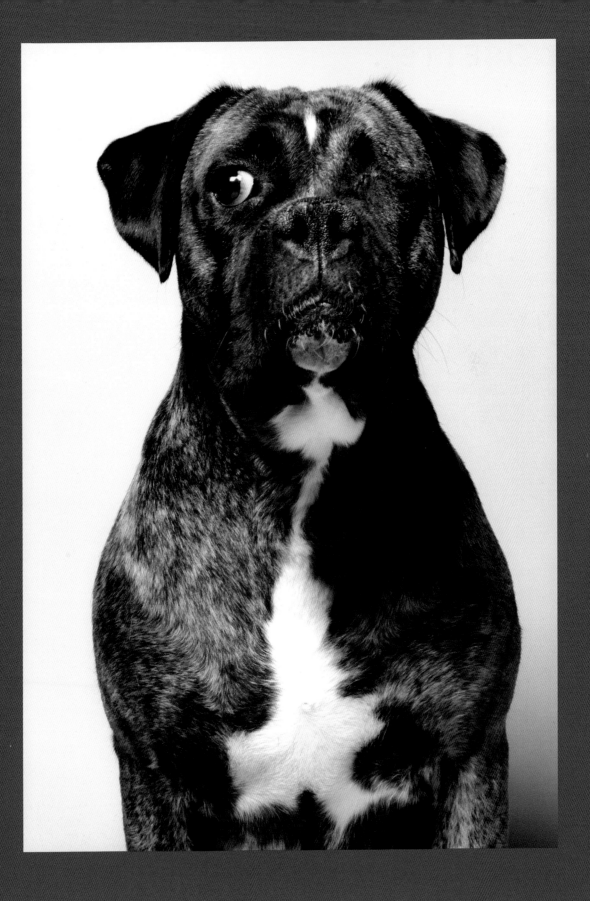

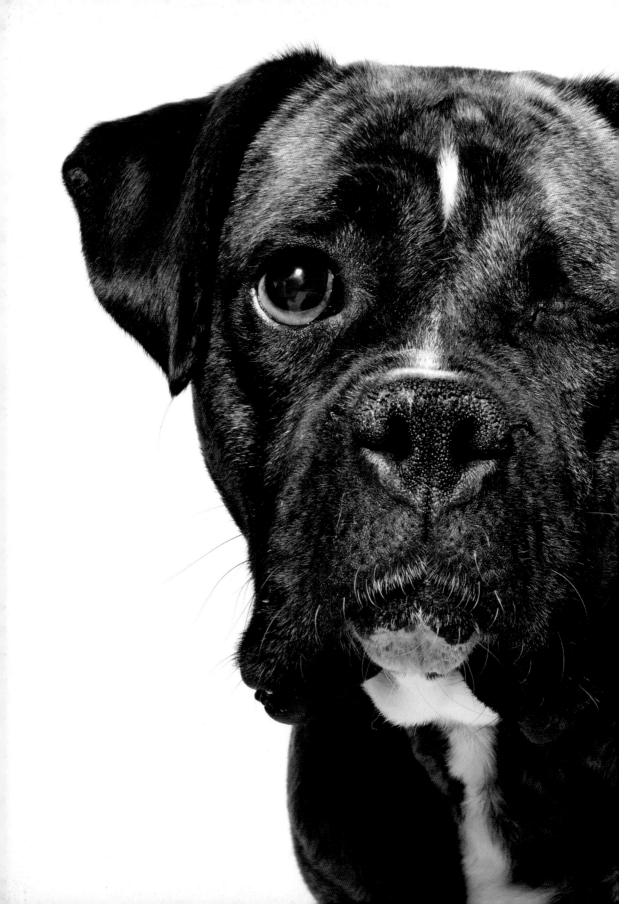

FREYJA

eight-week-old female pit bull puppy

Tallulah was tiny, emaciated, and sickly when she was brought to a rescue at six weeks old. The man who surrendered her told a dubious story about how he had won her from a pet store where a breeder had raffled her off. When questioned, the man said he didn't remember the name of the store and refused to give a home address. Later, it was discovered that he had also given a fake name. The staff immediately suspected that Tallulah was a product of backyard breeding practices or even perhaps from a property where illegal dogfighting was occurring.

She was admitted to emergency care where she tested positive for parvo and was found to be riddled with parasites. Two-pound Tallulah was given plasma transfusions and IV fluids but her outlook was very guarded. The rescue soon discovered that she had been taken to an emergency vet one week before but not admitted. Now she was fighting for her life in the ER. Three days later, her condition stabilized, and she was able to go to a foster home, where she continued to gain weight and become stronger. The shelter spent thousands on her treatment, which was donated by supporters.

The foster family made a makeshift ICU in their basement and Tallulah made a full recovery. A few weeks later, they decided to adopt her. A spitfire from day one, she was not afraid of the much bigger dogs in the house.

Tallulah (renamed Freyja) loves to climb and can even climb trees. Recently she learned how to swim by running off the end of a dock and suddenly finding herself in the water!

Like most puppies who are taken away from their mom too young, Freyja has a lot to learn. Her family is working on teaching her manners. Puppies learn how to behave from their mom and littermates, but Freyja never had that opportunity. She tends to overwhelm dogs because of her highly physical, overzealous approach. Her family reported that she does have several dog friends, all of whom are unrelated Great Danes.

Backyard breeders are damaging for many reasons, one of which is that they tend to sell puppies at very young ages in order to maximize profits. Separating a puppy from its mother at five or six weeks causes trauma. Even if these dogs luck out and get a good home, they inevitably develop behavior issues. Sadly, the kennels at shelters are filled with victims of backyard breeding. With firm but patient training and lots of love they can usually learn to be normal, well-behaved dogs. It's important to remember that a responsible breeder breeds for the love and health of the breed, with profit being secondary to producing healthy, happy dogs. A good breeder will never separate a puppy from its mom and siblings before eight weeks and often they will wait until ten weeks.

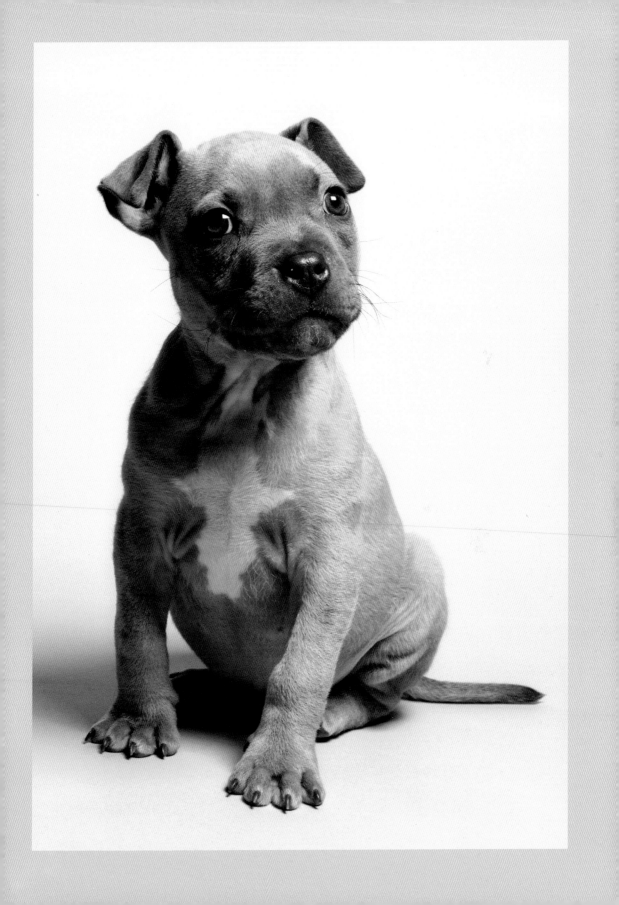

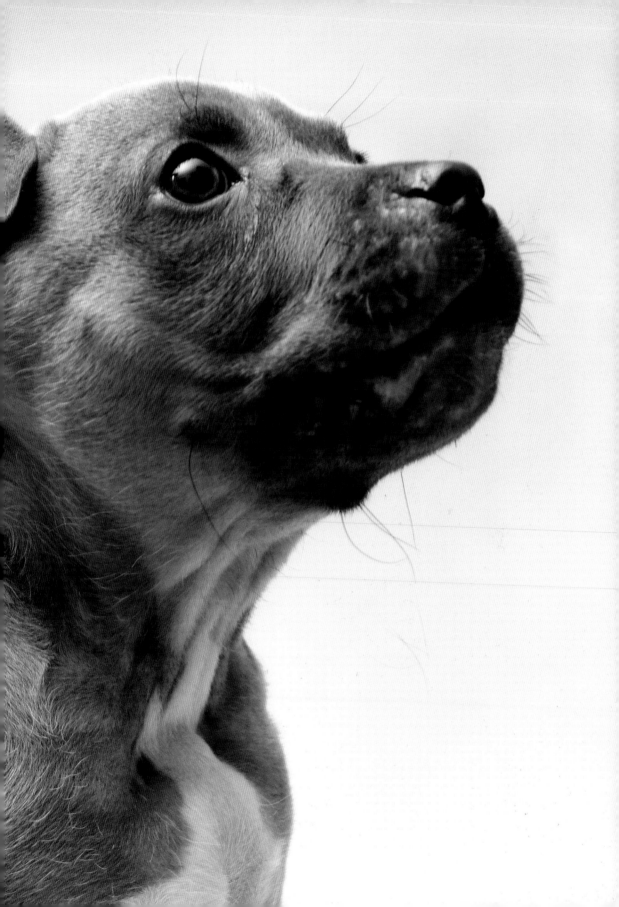

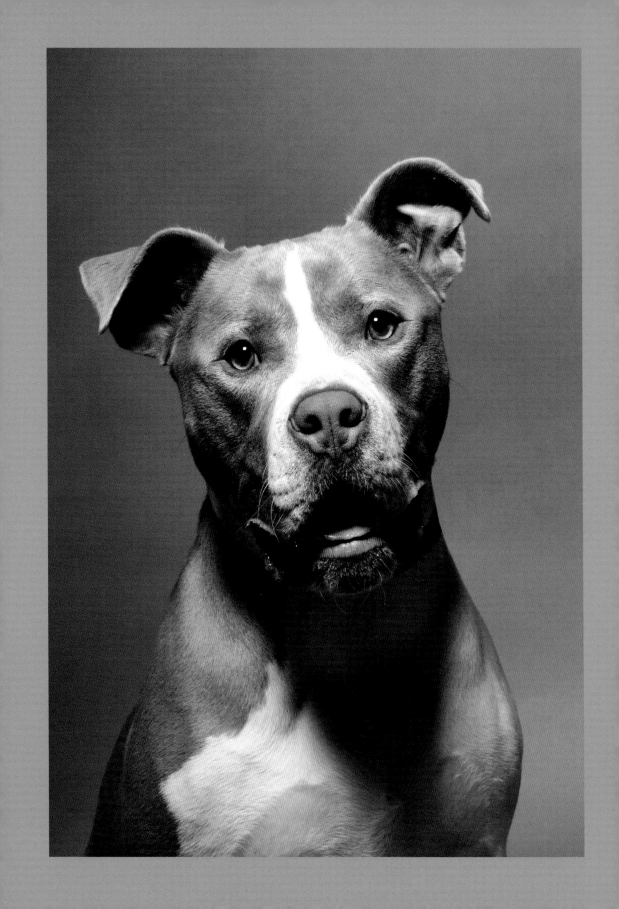

FROGGER

two-and-a-half-year-old male pit bull mix

Frogger was an owner surrender at a private shelter in February 2020 and ended up being the longest resident the shelter ever had—fifteen months from start to finish, during which time he had countless meet and greets and was adopted and returned three times.

Frogger's original owners had bought him as a puppy and had never trained him. As is often the case with unneutered, untrained males, he quickly became too much to handle. Frogger was easily excited and had a hard time calming down. He jumped, mouthed hands and arms, and bit at clothes. These behaviors are annoying and cause for concern with any dog, but in a large, powerful dog they can be dangerous even when they aren't intended as aggression. Most mouthy dogs are simply excitable, not aggressive, but they often don't know when to stop and can easily puncture skin or overpower someone.

Frogger was immediately neutered, and the shelter started behavior modification training. Soon he was adopted, but he was returned after only twenty-four hours. The adopter was honest and confessed that he had underestimated the amount of work the dog required. Frogger was still mouthy, peed on everything in the house, and had no concept of a home environment. But despite his rude behavior, the staff saw potential in him. They didn't think he was a danger and were determined to keep working with him.

Frogger is a handsome dog, and over the months he caught the eye of many visitors, but most homes were not right for him. Eventually, he was adopted for the second time by a single man who had him for two weeks before he called and said that he needed to bring Frogger back. He was scaling the six-foot fence in the backyard and getting loose. The man was worried that Frogger would get hit by a car, as his obsessive behavior drove him to climb the fence over and over again.

Frogger's third adoption in May 2020 was by a woman who was sure that he was the right dog for her and that she would be able to handle him despite the shelter staff having considerable doubts. Her boyfriend was a construction worker, and he was going to take Frogger to construction sites every day. A few weeks later the woman called, upset and frightened because his constant mouthing was hurting her. Frogger was returned to the shelter again.

After his third fail, Frogger was taken off the adoption floor for prolonged, intense behavior modification training. His trainer at the shelter took him on as her special project even though she was discouraged and secretly feared that he would end up being euthanized. He was a lot of dog to handle. She couldn't make eye contact with him; he would body slam her and mouth her arms and legs. Though he never broke skin, he left her arms covered in bruises.

Totally drained and watching his behavior deteriorate in the shelter, she contacted an expert foster home to see if the woman would take him on weekends to give him a break from the stress of the shelter.

Frogger began taking weekend visits to the foster home to decompress and to improve his behavior for adoption while slowly acclimating to a home environment. As the months went by, the shelter became increasingly stressful for him, so his foster mom, who is also a trainer, stepped up and offered to take him on full time as of September 2020. Frogger was finally getting what he needed to succeed: training, exercise, enrichment, and bonding time in a home setting every single day. By getting out of the shelter and into a foster home, Frogger learned how to behave in a home as well as how to play with other dogs. He became a more lovable dog, one you could actually enjoy being around.

In December 2020, a potential adopter applied for one of the dogs that Frogger's foster mom was working with in a local shelter. He was looking for the right dog to take to work with him at his gym every day, and although the dog he applied for wasn't a fit, he decided to start volunteering with some of the foster dogs. He began taking Frogger on walks and field trips every week and over several months the two built a strong bond. Frogger's foster mom says that she and Frogger knew he was

Frogger's person way before he did, but he figured it out in the end and adopted him in May 2021. Finally, Frogger, the dog who seemed destined to fail, had found his happily ever after.

A strong stigma has grown up around returning dogs to shelters or rescues. I see families who make this difficult choice abused and bullied on social media and most of us in the animal welfare community believe this shaming has to stop. If the home isn't right, it is better to return the dog and give them a chance at finding the right home than for people to keep a dog they can't properly care for. Adopters should not feel shame about returning a dog, especially after reaching out for help and knowing that it still just won't work. Keeping a dog you don't connect with or can't control is not healthy for anyone. That being said, I do believe there is an adjustment period after an adoption when a new family member, no matter how good a fit, can seem very overwhelming. Most shelters or rescues are happy to field follow-up questions and offer transitional support to their adopters. In many cases, they will also offer free training to recently adopted dogs, but they will also always be willing to take a dog back.

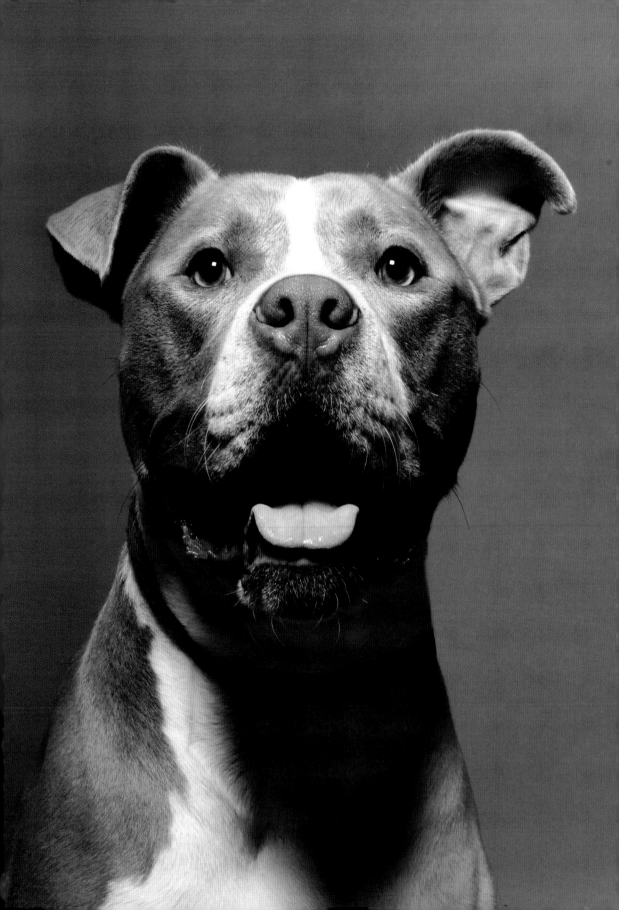

GOV'NOR

nine-month-old male French bulldog mix

Gov'nor was seized in July 2020 along with five other dogs from a property whose owners were engaged in backyard breeding. All of the dogs were victims of neglect and unethical breeding practices and needed significant medical care. Gov'nor had cherry eye and melting corneas in both eyes, a soft palate that extended into his trachea, hip dysplasia, skin issues, and splayed front legs from being constantly confined in a small crate. A plea bargain was made with the owner, who agreed to legally sign the dogs over in exchange for lighter prosecution.

Gov'nor and the other dogs had to be placed into experienced long-term foster homes while they received critical medical treatment. Due to the extent of Gov'nor's physical problems, there was a chance that even after he was treated his quality of life would not be acceptable, and he would not go up for adoption. His foster family had to be prepared for the possibility that he would need to be humanely euthanized months down the line.

When Gov'nor was first rescued, his front legs were so splayed that he didn't walk at all and just laid flat in his kennel. The vet thought that he might need surgery to put plates in his legs, but he began to walk after building up enough muscle to support his weight. His cherry eyes were removed, and he was given medicated baths and ointments for his skin and braces to help straighten his legs.

His foster mom took him with her to work every day. Gov'nor loved to ride in the car. He was loving and social and seemed genuinely grateful for each day. After he received soft palate surgery and could breathe well for the first time in his life, he was transformed. Suddenly he was running and playing and acting like a normal happy dog.

Gov was adopted in October 2020.

Backyard breeding is breeding that is considered substandard and performed by amateurs with little or no regard for producing healthy dogs. Backyard breeders often run small commercial operations where they conduct experimental selective breeding in order to generate the most possible profit. This is in sharp contrast to a responsible breeder, who will generally be well established and have extensive knowledge of the breed they represent. Above all, a responsible breeder strives to produce healthy, happy dogs and will stand by their dogs for life. The vast majority of dogs in shelters are products of backyard breeding or accidental breeding. If you suspect that someone in your community is engaged in backyard breeding and that animals are being neglected or abused, voice your concern to local law enforcement or to your local shelter.

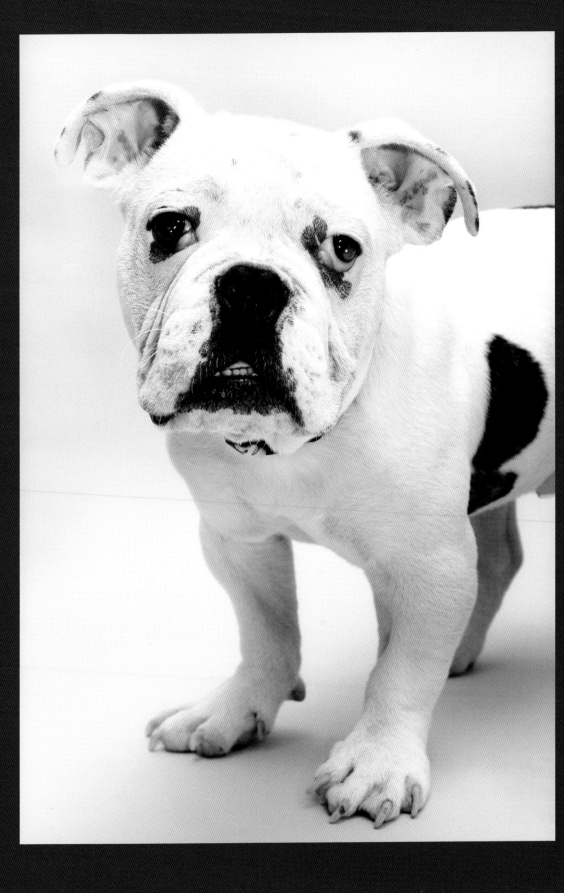

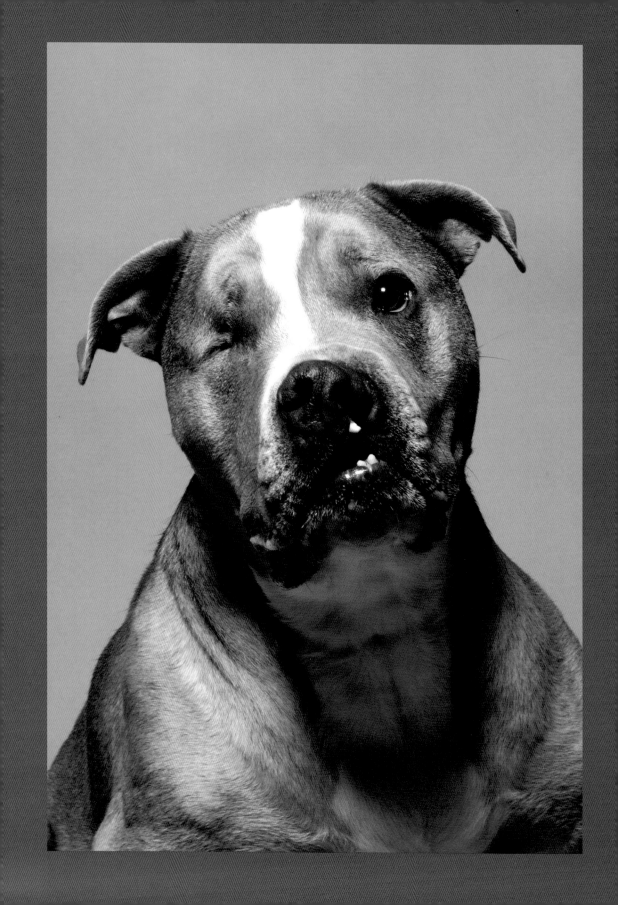

HARVEY DENT

seven-year-old male pit bull mix

Harvey was brought by his owner to a private shelter to be euthanized in May 2014 when he was just four weeks old. Born with a cleft palate, he was malnourished and his right eye was ruptured and hanging out of the socket due to unknown trauma. The shelter staff asked for the opportunity to save him rather than euthanize him. The owner, a known backyard breeder, agreed to sign him over.

That night, the tiny puppy was taken home by the shelter's dog care coordinator, who christened him Harvey Dent. Harvey proved to be a lot of work. He needed frequent feedings followed by baths to clean the mess he made with the formula mash he was learning to eat on his own. Desperate for a mother, little Harvey followed the coordinator's female dog around, trying to drink from her empty nipples. The resident dog was annoyed and definitely not interested in being a surrogate mom to this needy little pup.

Harvey needed a permanent foster home able to handle all of his needs; one soon offered to take him on full time. Amazingly, one of the resident dogs at his new foster home, a rescued German shepherd, immediately stepped up and took on a maternal role. She cleaned Harvey, kept him warm and safe, potty trained him, and raised him as if he was her own puppy. The foster mom watched as a beautiful bond grew between these two dogs who had both been discarded.

Harvey's ruptured eye was painful, resisted healing, and would never have sight, so at eight weeks the vet removed it, giving him what his mom calls "a permanent wink." He was returned to his foster home and started making appearances at shelter events, wooing potential forever families. Once he was fully healed, charming Harvey was put up for adoption.

An ideal family with two kids and two dogs fell in love with him, but when their senior dog met Harvey, he was less than impressed. Several further meetings yielded no change. The dog did not want a puppy in the house. The family, determined to do the right thing for their current dogs, declined to adopt Harvey.

As the shelter continued to search for the right home, they asked Harvey's foster mom to bring him back so that he could be seen in the kennels when people came through. The suggestion ended up being just the push Harvey's foster mom needed, and she adopted him in August 2014.

Like most dogs with disabilities, Harvey doesn't realize that he is different from any other dog. Handsome and loving, he is a fast favorite everywhere he goes.

Taking your current dog's needs into consideration when adopting is essential. Whenever possible, it's really important to make sure that the dog you're interested in adopting meets everyone in the house, including your current dog(s). While in many cases dogs may come around to a new member, there are just as many times that they don't. Forcing a sibling on a dog can result in depression, aggression, or even chronic health problems.

HOSS

seven-year-old male boxer mix

Like many dogs who come through the shelter system, Hoss has experienced a lot of upheaval in his short life. He was surrendered to a private shelter in February 2021. His owner was moving out of state for a new job and felt that he would not be able to give Hoss the time and affection he deserved. Hoss's owner had originally adopted him off of a community Facebook post three years prior. His former owner was a truck driver who had taken Hoss with him on his trucking routes. This man had also been moving out of town when he needed to "re-home" Hoss.

Hoss had a history of having small masses on his body. His owner had gotten some of them removed and had been told that they were benign. At the time of surrender, he had multiple masses on him. The shelter did basic lab work, which came back abnormal. Hoss stayed in the shelter for weeks, undergoing medical treatment. Ultrasounds found masses on his liver, but to learn if they were benign or malignant would have required an invasive procedure. If the masses were malignant there would have been no viable treatment option, so the shelter chose supportive care.

Hoss was a very shy dog, and living in a shelter, rather than a home, stressed him immensely. He became very anxious, even panicky, and couldn't be given any meds to relax because of his liver issues. The shelter didn't want to send him to a foster home because they were concerned that his health problems might be severe enough to require euthanasia, and they didn't think they had a foster family who could handle that blow.

All of the staff and volunteers loved Hoss and were cheering him on. In April 2021, he was adopted as a hospice adoption with suspected liver disease. There is no cure, so his condition can only be managed. The goal is simply to make him comfortable and shower him with love for what remains of his life. In his new home, Hoss's anxiety decreased instantly. Though he will need constant diet and medical regulation, he is now safe and happy. To this day Hoss loves car rides.

It's tough not to judge surrender situations, but it's also important to remember that judgment doesn't help the dog and just drains those trying to help it. If an owner works fifteen hours a day, for example, and can't give the dog the attention it deserves, then surrendering that dog is actually a kindness. It's far better to give the dog a chance at finding a happy life with the right family than leave it to live out its years being neglected. However, it's also important to remember how stressful shelters are for dogs. Fragile, sensitive dogs don't do well in shelter environments. They will often become depressed, anxious, or subject to full-blown panic attacks in kennels—a fate worse than death, as many shelter workers can attest. In Hoss's case, his owner may have misjudged Hoss's needs. Being a very mellow, middle-aged dog, he didn't need much in the way of exercise or stimulation and probably would have been quite happy to lie on a couch all day.

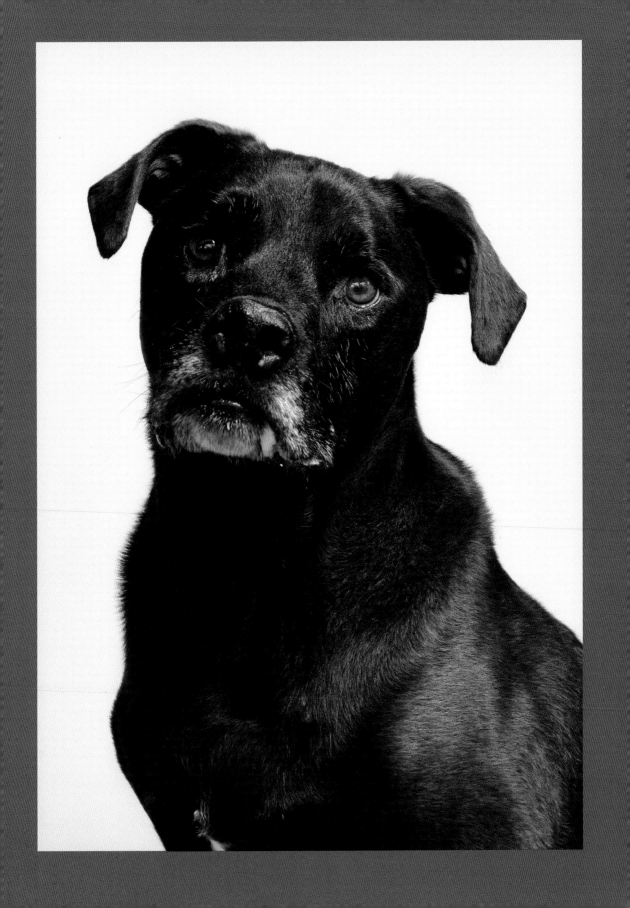

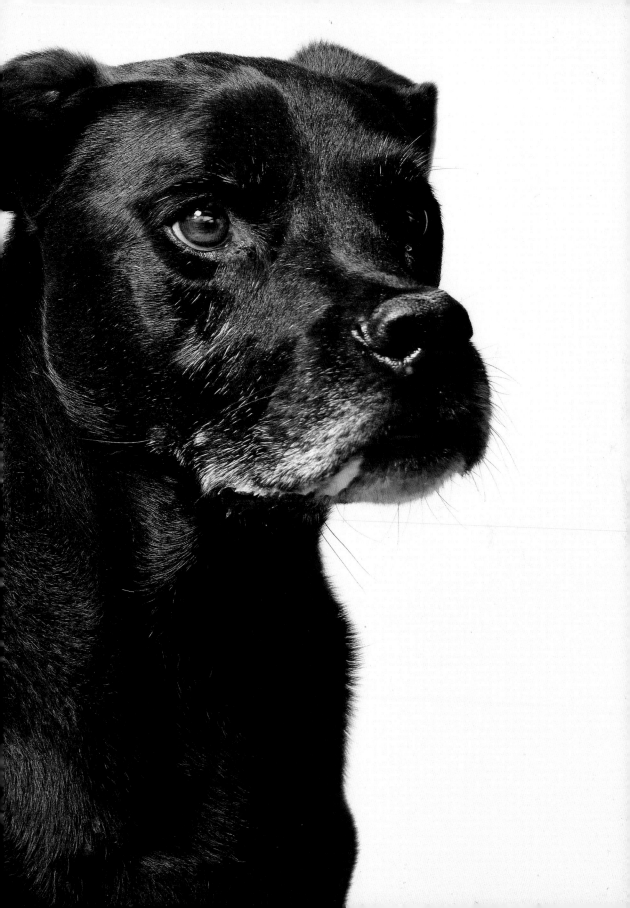

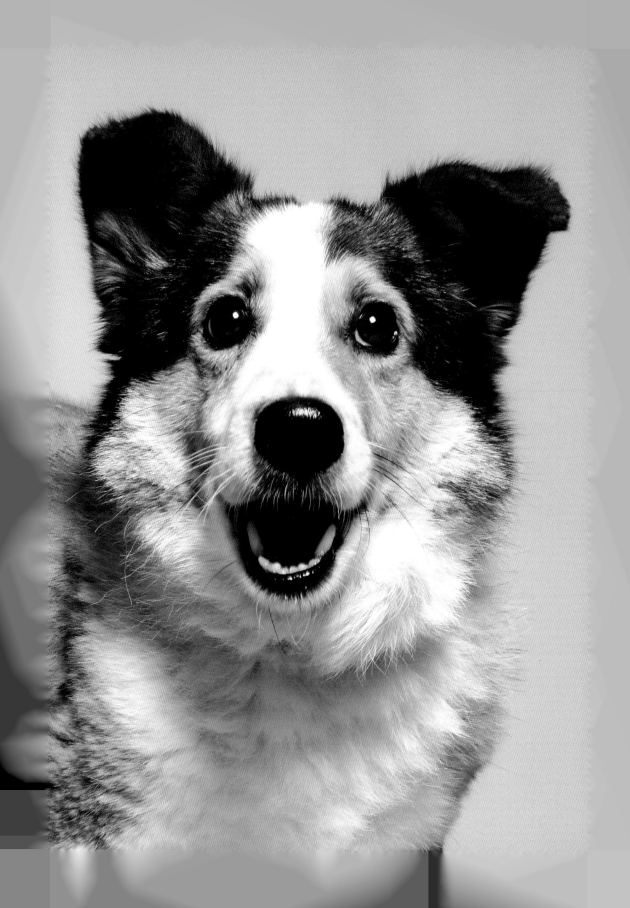

IZZY

five-year-old male Shetland sheepdog mix

Unlike many of the dogs in this book, Izzy was fortunate to have been owned and well loved by one person for most of his life. But when his owner became ill and could no longer care for him, he was brought to a South Carolina municipal shelter along with his bulldog sibling. For some reason, the bulldog was immediately adopted out, leaving sweet Izzy alone and in need of a home. He was put into foster care for one week and then sent as a transport to Rhode Island in May 2021.

In their report, Izzy's foster family in South Carolina repeatedly mentioned what an amazing dog he was and that he was the easiest and most well-adjusted foster they'd ever had. Izzy is good with dogs, cats, and kids, quite the unicorn in the rescue world. Like many folks, the foster family had assumed Izzy was a female due to his name and fluffy appearance; they made sure to note that he was in fact male. Izzy was cheerful, gentle, and affectionate, and he became an immediate favorite at the shelter. Considered a highly desirable dog in New England, he was adopted in less than a week.

Transport brings dogs like Izzy and other desirable adoptable dogs to parts of the country that have few or no dogs available for adoption, while also helping to alleviate overcrowding at high-volume shelters. Shelters in many areas like New England are virtually empty thanks to effective spay/neuter laws, clinics, and humane education. There is no one-size-fits-all dog, but because of transport, many people who want to adopt but are frustrated by the lack of options can save a life and find the right dog for them.

MAJOR WALTER VON BURGER

male pit bull

Walter's story has as many twists and turns and name changes as a long country road, which is exactly where it starts. He was found as a stray in a Mississippi county where there is a pit bull ban. Because of that law, any pit bull who is picked up cannot be put up for adoption but is instead immediately euthanized. Fortunately, when Walter came in, someone at the county shelter saw how special this pittie was. They managed to sneak him out to a rescue, where he was named Gator and treated for heartworm disease. The head of the rescue fell in love with his big, goofy grin and constantly wagging tail. She wanted to keep him, but her partner said, "No more dogs," so she arranged for him to be transferred to Rhode Island.

Halfway to Pennsylvania, where Gator would be handed off to a volunteer from the Rhode Island rescue, her partner called and said he'd had a change of heart. By this point, however, she had already come to terms with not keeping him and continued driving to Pennsylvania.

Gator was renamed Major by the new rescue, which immediately placed him in a foster home.

The foster home also fell in love with Major and seriously considered keeping him, but they had just lost their dog and weren't quite ready for a new family member. Meanwhile, a local animal behaviorist was also grieving the loss of her beloved dog. The woman had become very depressed since the passing of her sixteen-year-old pit bull. She had stopped working, found no joy in life, and couldn't leave the couch.

She and her husband wanted another dog eventually, but it seemed too soon; rushing to fill the emptiness felt like a betrayal of the dog they had just lost. Plus, in a household with cats, chickens, and ducks, they would need a dog who was mellow, friendly, and good with pretty much everything under the sun, a total unicorn in the rescue world. Less than one week later she heard about Major.

Major sounded perfect. He checked all the boxes: no aggression, no anxiety, good with both cats and dogs, and super social. She decided to have him meet the ducks and chickens, assuming that would probably be

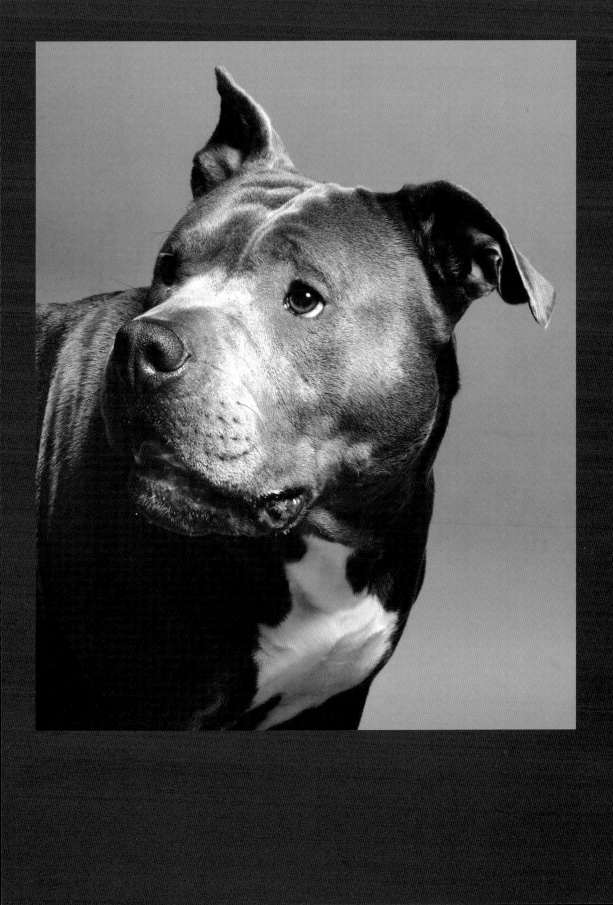

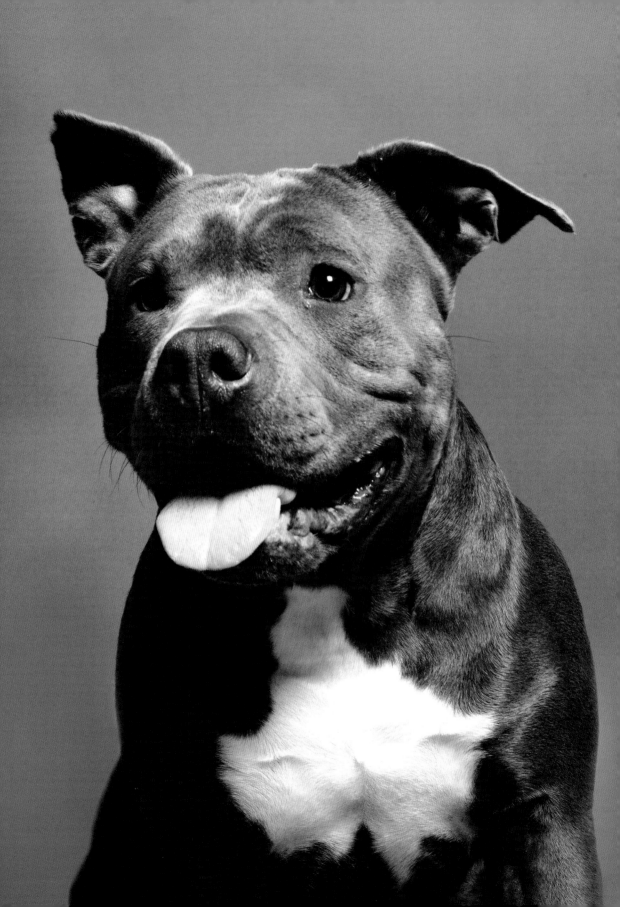

a deal breaker, but he was great. Then she decided to have him meet the cats. Once again, he was great. Next, she decided to have him stay overnight just to see what it would be like to have a dog in the house again. He was still great, and overnight turned into a week, which soon turned into a month.

As soon as Major had arrived at the behaviorist's house, she of course had to walk him, train him, care for him. She had no choice but to get up off the couch and engage with life again. Soon she found herself meeting up with friends so that Major could have play dates. After one month of fostering him, during which time he had been tested with kids, dogs, strangers, and everything imaginable, the couple adopted Major and renamed him Major Walter Von Burger, Walter for short. He "found" his person at just the right time, and brought her out of her grief and back to life—as dogs are so good at doing.

Breed-specific legislation (BSL) are laws that regulate or ban specific breeds of dogs in order to try and decrease dog attacks on humans. These laws are almost always aimed at pit bull and pit bull-type dogs. There is no evidence whatsoever that BSL works and in fact the CDC strongly opposes it. All too often, as in Walter's story, BSL causes innocent, adoptable dogs to be euthanized for no other reason than that they fit the profile of the banned breed. Dangerous dogs come in many shapes, sizes, and breeds, which is why in twenty-one states, breed-specific laws themselves have been banned in favor of laws that track and regulate individual dangerous dogs regardless of breed. However, more than seven hundred US cities currently have breed-specific laws in place. If BSL is suggested in your town, raise your voice!

MAMA GIGI

two-year-old female border collie mix

Mama Gigi wasn't a mama when she came to her foster home—not yet, anyway.

Her foster mom was told that Gigi was due any minute, but it's often a bit of a guess with rescue dogs. Gigi's foster mom likes to say that Gigi was the first "puppies on the inside" foster she ever had. Up until then, she had always taken moms with puppies "on the outside," meaning that they had already given birth.

Not much is known about Gigi's history except that she was pulled from a rural shelter with a high euthanasia rate and taken in by a large private rescue. She was exceptionally friendly the second she came out of the travel crate and always wanted to be with people. Usually, her foster mom quarantined any new arrivals for five days to keep her own little pack safe, but Gigi wouldn't allow it. She insisted on being with her and her five dogs as soon as she arrived. A charming young dog, Gigi would roll over and offer her belly anytime her foster mom would say, "Show me your puppies!"

Gigi eventually went into labor at two in the morning eight days after arriving. By then her foster mom was really excited to experience the miracle of birth alongside her, but twelve hours later Gigi was in intense labor and there were still no puppies. Eventually her foster mom had to leave the whelping room to take care of her other dogs. When she came back, there was a puppy delivered, cleaned up, and already nursing. She cursed herself for having missed it and was determined to not miss the next one. After another two and a half hours, she noticed Gigi having a strong contraction, but no puppy came out. She stepped outside again, came back, and there was a second puppy, also cleaned up and nursing. It was then she realized that despite Gigi's highly social nature, she wanted to have these puppies alone.

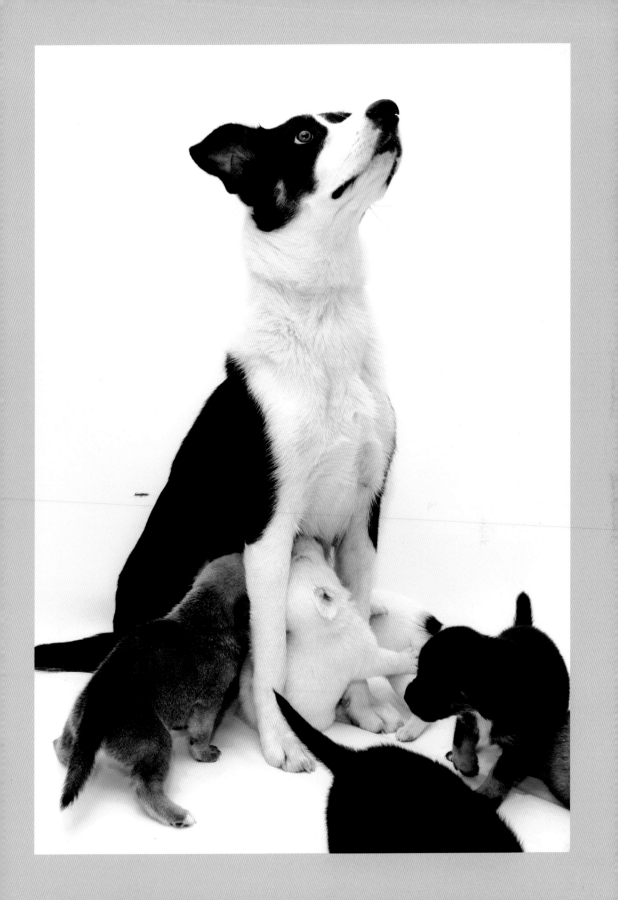

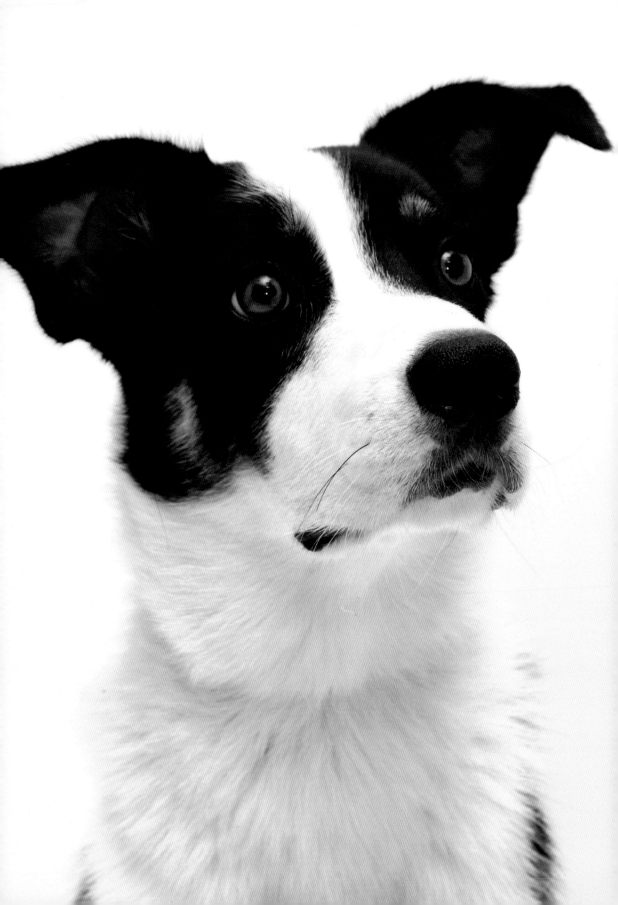

A third puppy emerged seemingly by accident while her foster mom was still in the room, but that puppy was followed by another long pause. Finally, except for some quick check-ins, Gigi's foster mom left the room for good while she delivered her remaining three puppies.

The litter was nicknamed the "Galaxy" litter and the pups were given names like Andromeda, Pinwheel, and Sombrero.

Gigi was a good mom for the first week, but after that she didn't want to be alone with the puppies—she wanted to be with people. Her foster mom had to sit in the room with her in order for her to nurse, which meant getting up several times a night. The third week, Gigi became impatient with nursing even if someone was with her. She wouldn't stay still and was easily distracted. It soon became clear that she would never make it eight weeks with the puppies, so her foster mom had to start weaning the pups at the end of three weeks by making them plates of milk replacer. By five weeks, Gigi no longer wanted anything to do with the puppies. She didn't want to be a mama dog—she wanted to be a human companion.

Gigi assimilated back into the regular household and lived with them for another three weeks, after which she returned to the rescue and was put up for adoption. She was adopted within a few days. Her puppies stayed in their foster home until they were ten weeks old and ready for their new homes. Gigi's foster mom has cared for one hundred foster dogs and puppies since Gigi came to her in October 2020.

MIA

thirteen-week-old female Boston terrier

In May 2021, a lactating border collie got loose from an Amish puppy mill in Pennsylvania and was picked up by the local shelter. The rural community is small, so word got back to the mill owner that his dog had been found. When he came to claim her, he mentioned that he occasionally has puppies who aren't healthy enough to be sold and asked if the shelter accepted owner surrenders. They told him that they did and a few days later, he dropped off Mia.

Mia was eleven weeks old and weighed three-and-a-half pounds when she was surrendered. She was blind in both eyes from untreated infections. One eye had ulcerated. She also had a heart murmur.

Mia was put in foster care with a shelter volunteer and her wife. At first, she was small enough to fit in her foster mom's hand. But despite Mia's many health problems and her tiny stature, she was fearless. She faced down the foster family's three cats and three pit bulls with the bravery of a dog ten times her size.

After being treated with antibiotics for a few weeks, the infections subsided and one eye showed noticeable improvement. Though both eyes have scar tissue from the infections, she now has limited sight out of her right eye. She grew out of her heart murmur and was able to be spayed. She weighed fourteen pounds at six months—still petite, but well within the breed standard for a Boston terrier. Mia was adopted by her foster family and now runs the house.

Infections are rampant in puppy mills because of their overcrowded, unsanitary conditions. Dogs are generally kept in wire cages that are stacked one on top of the other, exposing them to the feces and urine of other dogs. In addition to cruel confinement, mill dogs are often given contaminated food and water and face a complete lack of veterinary care or basic grooming. As soon as puppies are old enough to be sold, they leave the mill, often with unseen health problems that will shorten their lives, while the breeding dogs remain in squalid conditions for years until they can no longer produce litters. Unfortunately, commercial breeding facilities are not illegal, so the best way to help end puppy mills is to never buy a dog from a pet store or online, and to support legislation aimed at improving conditions in commercial facilities and/or banning the sale of dogs in pet stores.

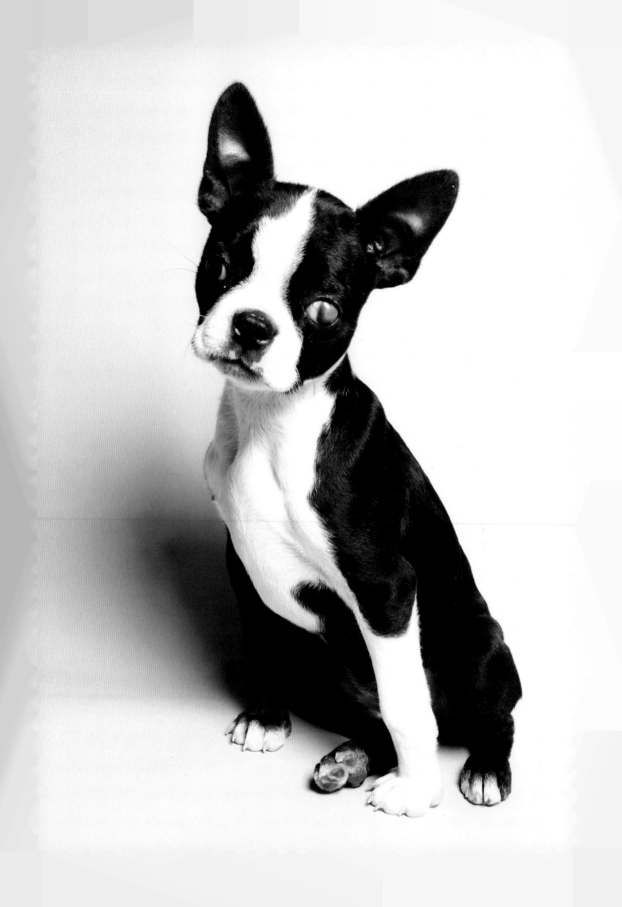

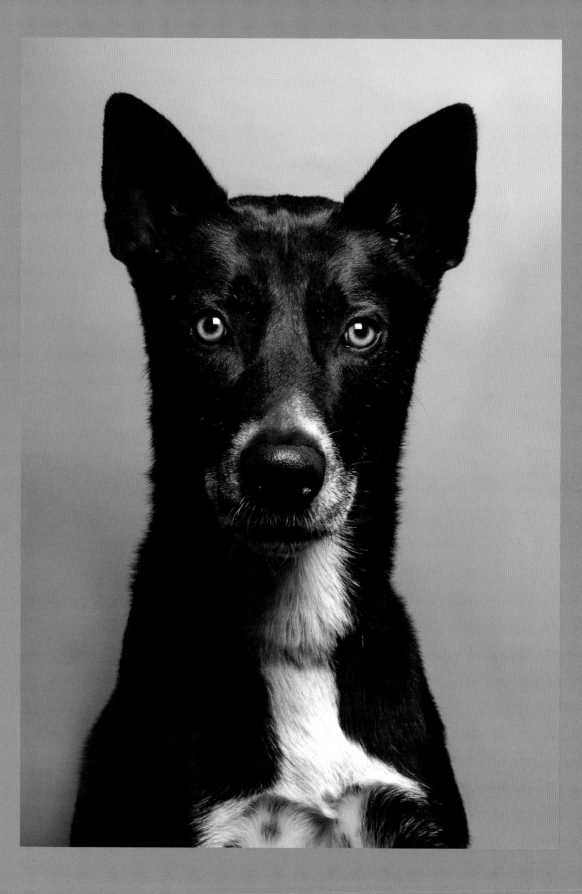

MILO

five-year-old male husky/AmStaff/malamute/cattle dog/mystery dog

Milo's owner always had dogs growing up, but when she became an adult, work and raising a young family took over. Although she hoped that someday she would have the time for a dog again, there never seemed to be a right moment. Finally, when her ten-year-old son started begging her for one, she decided that despite the strain of being a working single parent, she wanted her kids to experience the joys of growing up with a dog, so she jumped into the adoption process with both feet.

She knew without a doubt that she wanted a female dog and instinctively gravitated toward white dogs with floppy ears. After reaching out to several rescues, and often not getting responses, she connected with a helpful volunteer at a New England rescue that deals with transports from high-volume shelters in Texas. Worried about leaving a dog home alone all day, and interested in training the dog for therapy work, she knew she wanted an older, calmer dog who could be taken to her job as a licensed mental health counselor.

After the woman lost out on several dogs over the span of a few months, the volunteer called and said she had the perfect dog. He was a two-year-old male, solid black with stand-up ears—he didn't fit even one of her criteria, but

his picture melted her heart, and she drove to an adoption event to meet him the following weekend. This time, she was determined not to be the second or third applicant, so she got there early and waited just inside the door, hoping to be the first person to greet him.

He was shaky and thin and sweet, and she knew almost instantly that he was the dog for her. After about ten minutes of meet and greet, another family expressed interest, so she quickly handed over a check that she had written ahead of time. The rescue wisely required that dogs meet all family members before an adoption can become official, so they scheduled a family meet and greet for two days later. She kept the dog a surprise for her three boys, and when the foster father walked him through the back door, she told her kids that someone special was there to meet them. Soon everyone was crying and welcoming their new family member, Milo.

After an adjustment period, she decided she definitely wanted to pursue pet therapy with Milo and found out what was required to become certified. She had plans for him to be an office companion, but Milo had different ideas. After basic training, the second phase of the class involved taking the dogs to an

assisted-living facility. It was there she suspected that Milo was never going to be the kind of dog who climbs up into a lap and falls asleep or comforts people in hospital beds. He was curious, energetic, and didn't like staying in one place too long. He wanted to meet as many people as possible.

During the final phase of training, Milo had an internship at a library, but as suspected, he was not interested in lying down and letting kids read to him; he was much more interested in roaming the library and interacting with everyone. Milo's mom soon realized that Milo was a greeter, not a comfort dog, so she modified her dream to fit his personality.

Milo has worked some very important jobs over the years, including providing support and love at a camp where siblings currently in foster care but living in separate homes get to spend two weeks together. He has also been at adoption days when families gather to make their child's adoption final at court. Milo's favorite job, though, is as a greeter at a courthouse, where he stands near the door to welcome people and walks up and down the hallways to mingle with those who are waiting to go into the courtrooms. When someone shows interest in him, his owner

walks him over to let them pet him. He gets to meet dozens of new people and provide a little bit of stress relief for folks during what is often a very tense time. Recently he received an American Kennel Club Therapy Dog Excellent (THDX) title after logging two hundred hours of service.

Having worked in a shelter for more than ten years, I can remember countless times when people came in or emailed all excited to meet a particular dog they had fallen in love with online, or who looked like the dog they had as a kid, only to realize during the meet and greet that this dog was not a good fit for them. It's disappointing when this happens, but hopefully in these situations the volunteer or staffer will suggest another dog based on what they have learned about the person's lifestyle. When I did this, more often than not, the person would end up adopting the dog I suggested. Picking a dog based on a photo alone rarely works out. When it comes to adoption, it's good to keep an open mind as to what you're looking for, especially where looks are concerned, because ultimately, the dog you think you want because of its cute ears, fur color, or even age may not be the dog you need!

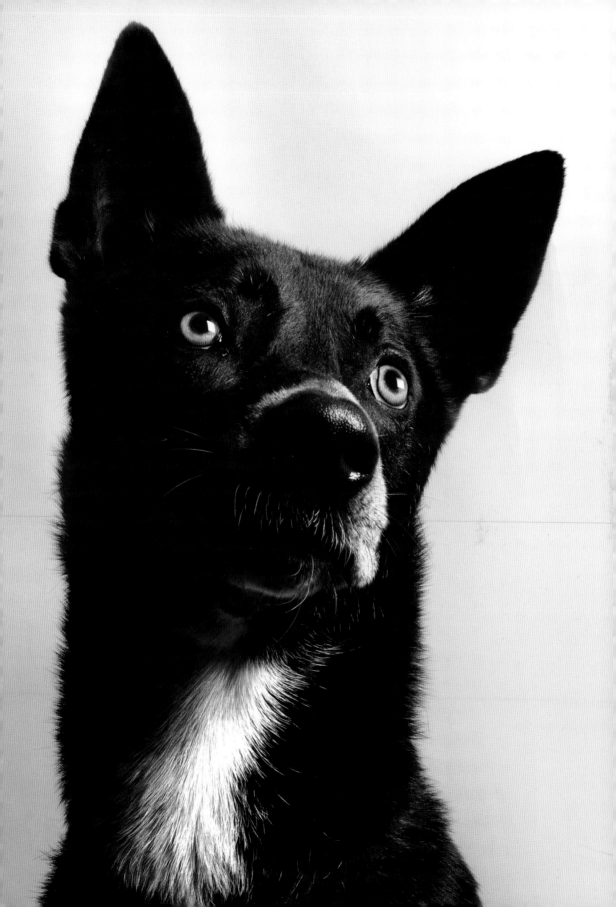

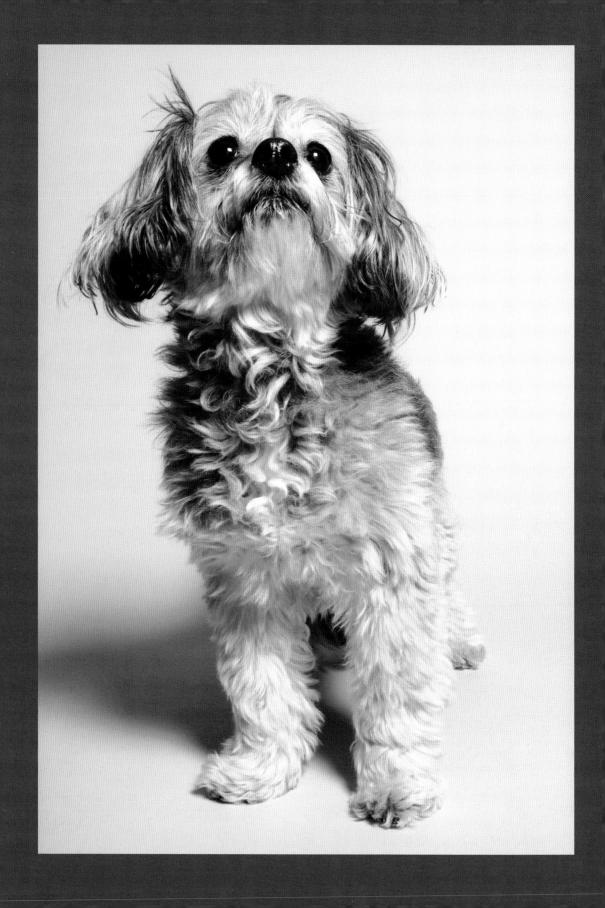

MOLLY

ten-year-old female shih tzu mix

In 2015, a couple started looking to adopt a third dog to add to their family. They found a rescue who piqued their interest and went to the shelter for a meet and greet, where they quickly realized that they didn't click with the dog. The shelter kept smaller dogs in its office during the day, and while the couple was there chatting, they noticed a small, golden-brown dog named Scrabble. Scrabble had been a breeding dog in a puppy mill, and the farmer had surrendered her to the rescue. She was approximately three years old. When they met Scrabble outside, she was very relaxed and at ease with them. She even let them pick her up and hold her, flopping into their arms with no tension at all. Heartened by how much she seemed to like them, they agreed to adopt her.

The couple who wanted to adopt Scrabble had an invisible fence, which can be traumatic for skittish rescue dogs, so the shelter trained her on underground fence flags and then sent her "home." Everything went well at first; Scrabble seemed calm and easygoing. The other dogs in the house both had names that started with the letter *M*, so they changed Scrabble's name to Molly to celebrate her inclusion in the family.

After Molly had been in her new home for a day or two, her behavior began to change. She started to run away from her new family and hide, often under a bed where they couldn't easily reach her. Eventually the couple realized that Scrabble (now Molly) had not in fact been relaxed at all when they met her, but completely terrified. Going limp was her defense mechanism. It was only once she was more comfortable in their home that she even had enough courage to run away.

They also quickly realized that the warning beep of the invisible fence actually terrified her. She began refusing to go outside. On the few occasions when she did, she would take off and they'd have to chase her through the neighborhood. The couple quickly put up a physical fence and secured the backyard. They didn't know what to do except to give her space and just let her hide, hoping that she would "come around" soon, but after several months she was still terrified.

They wondered what they were doing wrong and were concerned about keeping a dog who didn't like or trust them, so they contacted the shelter for advice and hired a behaviorist, who said that she was in fact showing little hints of curiosity and advised them to just be patient.

Slowly but surely, Molly started showing some positive signs. The other two dogs would greet the women at the door, dancing, jumping, and wildly wagging their tails. One day Molly started joining in this ritual even though it was clear that she was still terrified of the couple and therefore not really sure why she was displaying this welcoming behavior. The happy, confident dogs she lived with were teaching her how to be a dog, even if she didn't quite get it yet.

It took a full year for Molly to choose to be in the same room with her people. She was still hiding under or behind furniture, but she was deciding to do it in the same room. Every morning, while their owners were getting bowls of kibble ready, the two other dogs would bark excitedly. One day, Molly's mom heard a very distinctive, deep bark that was unlike any she had heard from her dogs before. She thought she had imagined the sound at first but soon realized it had come from Molly, who had finally found her voice.

Two years into Molly's adoption, she is far from the timid little dog who hid under the bed. Her favorite place is snuggled between one of her people and the couch cushion, and at night she sleeps in bed between her two moms. At mealtime she jumps up and down, excited for her food to be served, and any guests who come to the house are met with her deep, assertive barking.

Watching and facilitating Molly's transformation was a deeply rewarding experience for the couple, and it inspired them to foster similar puppy mill dogs. Each new foster has a quiet, loving home to decompress in, a human at home at all times, and a house full of happy, well-adjusted dogs to learn from. They have fostered more than twenty puppy mill dogs since adopting Molly.

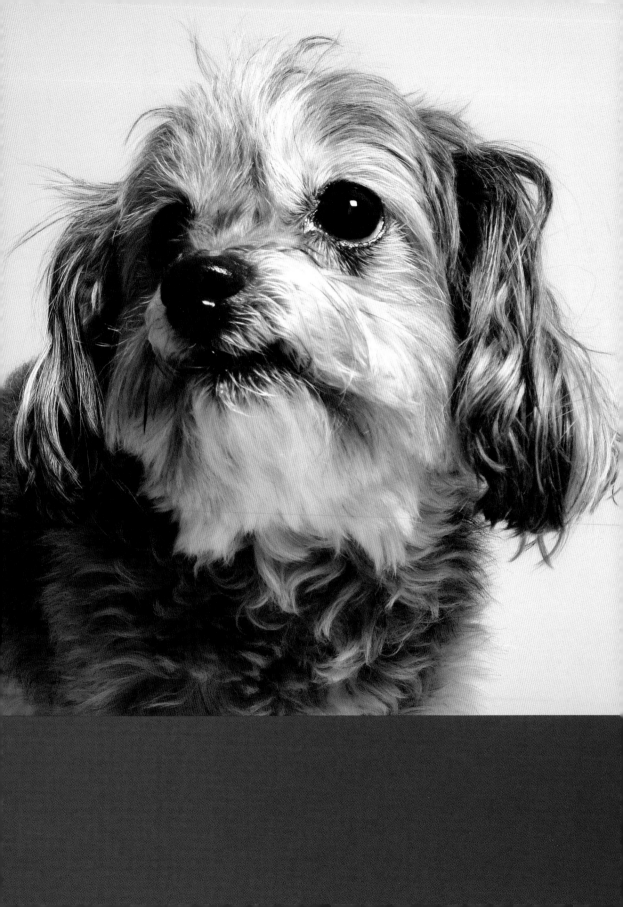

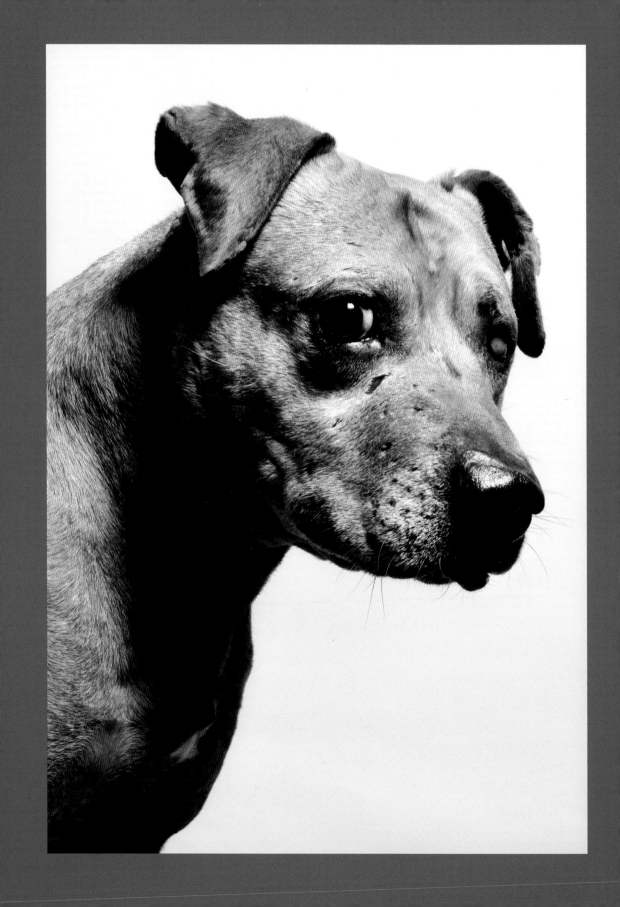

REMO & FABLE

eight-year-old male pit bull and five-year-old female pit bull

A barking dog complaint made to the local sheriff's office in Franklin, New York, in February 2020 led to the discovery of a dogfighting operation. Twenty dogs (later named the "Franklin 20") were all found living in a barn on a rural property. A Malinois, a German shepherd, and eighteen pit bull–type dogs ranging from nine weeks to eight years old were seized. The Malinois and shepherd were chained up and being used as guard dogs, while the pit bulls were in airline crates stacked on top of each other along a wall. The dogs were in a terrible state and their crates were full of vomit, feces, blood, and urine. Some of the dogs had active open wounds.

The local shelter is small: they receive a few strays and usually re-home unwanted dogs quickly. They couldn't possibly take all twenty of the confiscated dogs, so they split them up between three regional shelters. The shelter's vet had never encountered dogfighting before, as there had never been a local case.

Remo was the last dog taken off the property. While the other pits were in stacked airline crates, Remo was in a plywood box that was sinking into a dirt floor. He was the oldest dog in the seizure. He is eight but easily looks fifteen. A fighting dog's life is short and brutal.

When they found him, Remo was emaciated and had scars all over his face and neck, infections in his mouth, chunks missing from both ears, a puncture through one eye (which is totally blind), and all his upper teeth missing. His nails were immensely overgrown and infected, and he had babesia, a tick-borne disease found almost exclusively in fighting dogs. Even his tongue was scarred.

Remo had clearly been fought a lot, but all of his scars were healed. While he was past his prime, he may have been kept for breeding after his fighting days were over. He was terrified of everything. A foot-long scar down the length of his spine was one injury that indicated a human-inflicted wound. The abuse may have been intended to make him more aggressive, but it only traumatized him and made him more fearful. At the time of rescue, his spine was C-shaped from living in a crate that was too low to stand up or stretch out in.

Everything was a process for Remo as he tried to adjust to life in a loving home. Like most former fighting dogs, he didn't know what a dog dish or toy or bed was. He didn't know how to walk through a door or how to take a treat from a human hand. Despite his crippling anxiety, he allowed any and all handling.

Fight dogs have to be able to be handled even in the middle of a fight, so they are generally exceptionally tolerant of being touched by people. Remo's family was extremely patient and gave him all the time he needed to adjust. Although he is still petrified of strangers, when he is alone with his mom and dad, he is a happy, loving dog who enjoys hiking, does zoomies around the living room, and snuggles with them on the couch.

Fable was in many ways the complete opposite of Remo: she was young and had never been fought. At three years old she had no scarring and had most likely been kept as a breeding dog, but she too was terrified of people. When she first came in, she was emaciated and shut down like the rest of the dogs who were seized. Fable would face the cement wall in her kennel, lying on her blanket in a tight ball. She avoided eye contact and every sound was terrifying to her, every movement a threat. The director of the shelter felt an immediate bond with her, but she had an older dog and Fable needed to be the only dog in a home. Although she hoped to adopt Fable someday, she always promised that if the right family came along, she would let Fable go.

For many months, finding the right family seemed like an impossibility. Many potential adopters met Fable, but none were ever the right fit, so the director did everything she could to make her time in the shelter joyful. There is a little pond within walking distance where she would take Fable to swim. She loved to splash and dive under the water, frolicking around on a very long lead even in chilly temperatures. She would also spend some days at the town barbershop (owned by the director's husband), where she could mingle with the locals.

In July 2021, after Fable was at the shelter for seventeen months, a couple came to adopt a dog but found that they didn't connect with any of the ones available. Fable had always been kept separate from the other dogs because of her potential for dog aggression. The shelter director found herself saying, "Well there is Fable…" Despite thinking that it would never work out, she brought Fable out to meet them. Everyone knew almost instantly that it was a match. Fable was the dog for them. After a year and a half, Fable went home and for the first time in her life, now lives in a loving home. She has her own pond that she can swim in whenever she likes.

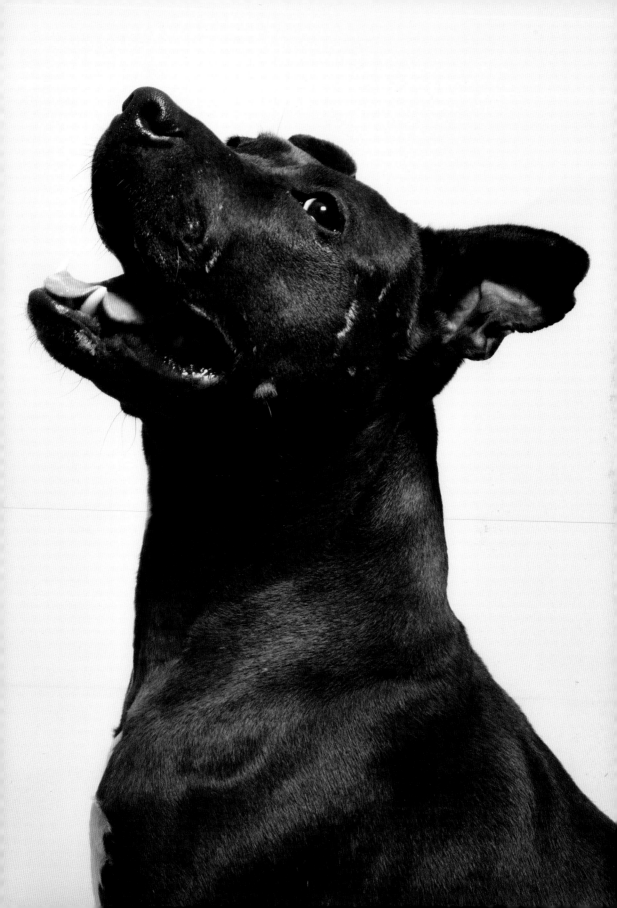

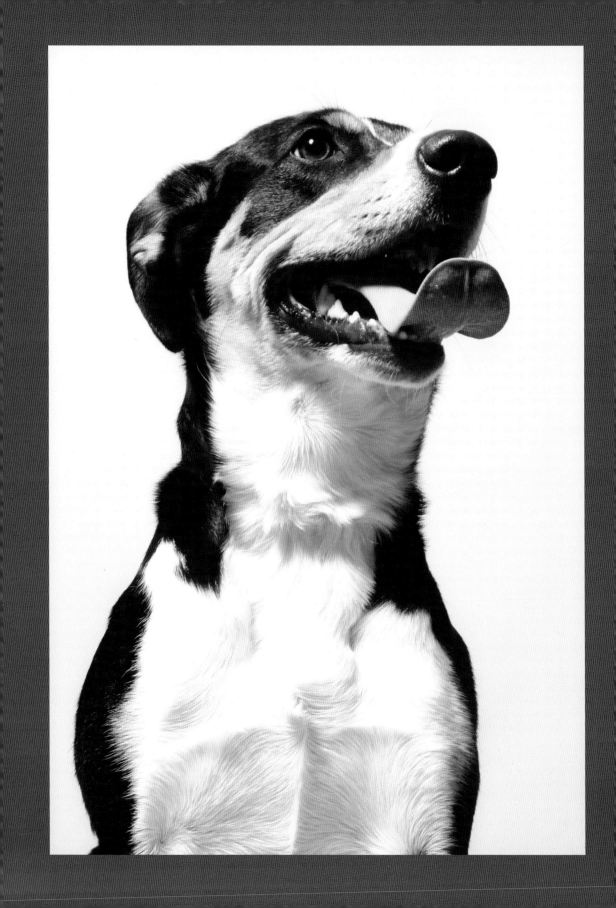

RILEY

one-and-a-half-year-old female mixed breed

Riley's dad was in tears as he stood in the lobby of the shelter. He had come to surrender Riley because he didn't have any other options. A veteran who had served in Afghanistan, he suffered from mental health issues and was going into a yearlong inpatient hospital program. He couldn't bring Riley with him.

Fortunately, the director of the shelter overheard the conversation and got involved. He quickly realized what a deep bond the man had with Riley and approached the foster coordinator to see if they had any families willing to take on a long-term foster. Luckily, they found a young couple, recently relocated to Rhode Island, eager to take Riley on.

Outgoing and happy, Riley fit in very well at her new foster home. The couple has two cats whom she enjoys watching and hanging out with. She is a young, very active mixed breed, so her fosters take her for daily walks and hikes as well as on outings to the beach and nearby lakes to make sure she gets all of the mental and physical stimulation she needs.

The foster coordinator continually reaches out for updates from the foster family, who readily share photos and information to pass along to Riley's dad, who checks in at least once a week. He is extremely grateful that the shelter was able to offer this solution so that he did not have to give up Riley. He and the shelter staff are looking forward to his reunion with Riley once the program ends.

SEAL

ten-year-old female pit bull

Seal was surrendered to a private rescue in 2018 along with another dog when their very elderly owner was moved into assisted living. Seal's body showed signs that she had been bred repeatedly, and she herself had most likely been produced by a backyard breeder. She had a history of untreated medical issues that were discovered when the shelter went through her vet records. Many were genetic issues caused by poor breeding. While the owner would faithfully take her to the vet when Seal showed signs of illness, she often had to decline treatment or further care because of the high cost.

Small, treatable issues built up over the years, just like they do in humans, and by the time Seal was surrendered, she had developed pyometra, a serious infection where the uterus thickens, develops cysts, and often fills with pus. Every heat cycle not resulting in a pregnancy increases a dog's chances of getting pyometra, which, untreated, can cause the uterus to burst. Soon after being relinquished, Seal was rushed to the emergency vet, where she underwent an operation to remove her enlarged uterus along with several large mammary masses.

Fortunately, Seal made a full recovery and was adopted. She still has a myriad of genetic medical issues that she will live with for the rest of her life, but she is happy and spoiled and exceedingly friendly.

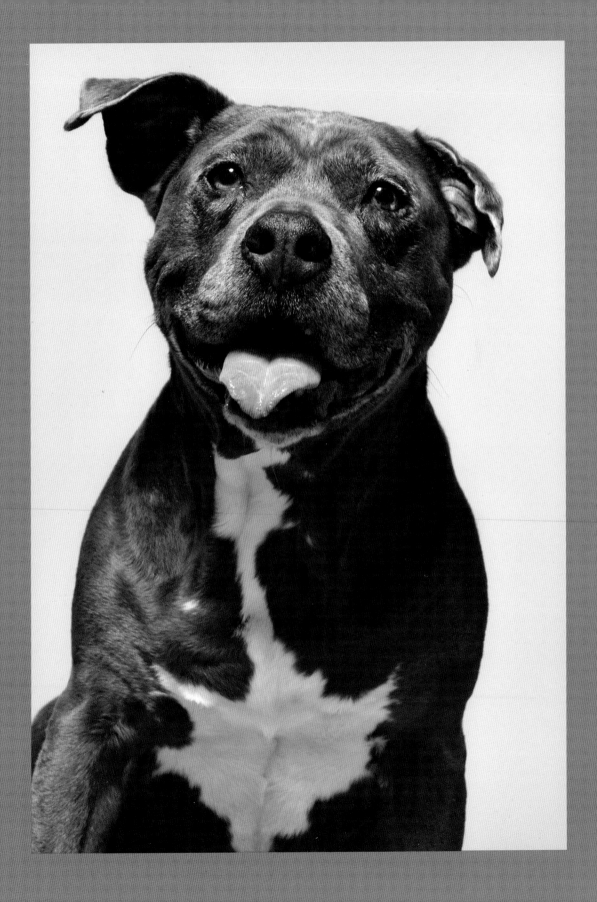

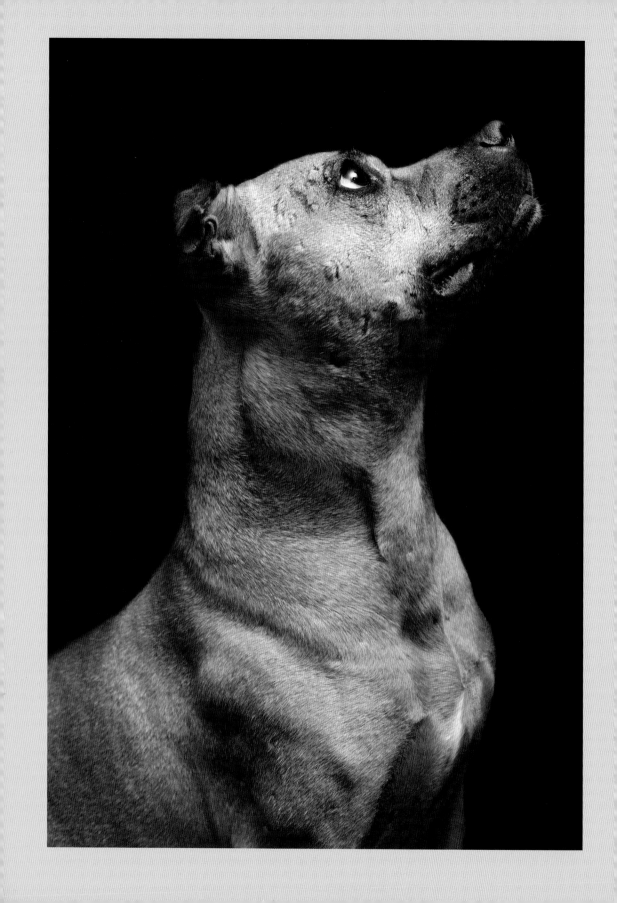

SESAME
age unknown, male pit bull

A well-known New England–based rescue for pit bull–type dogs received an urgent request to perform evaluations for twenty-three dogfighting survivors in Arkansas. There was no town shelter in the extremely rural area, so the seized dogs had been sent to a private rescue that had never dealt with dogfighting before. The rescue didn't want to euthanize the dogs, but they were afraid of them. They had asked for a national organization to come assist, but after a few months of waiting, they had run out of time. The civil case for the defendant was the next day, and they needed to decide whether to ask for custody of the dogs.

In a dogfighting case, the civil case determines custody of the dogs, who are considered property. Sometimes, defendants will refuse to sign the dogs over in order to use them as a bargaining chip in the criminal case. Until the dogs are signed over, they cannot be adopted out or even receive medical care unless the condition is life threatening.

The founder and behavior consultant of the pit bull rescue and an assessment volunteer got on a plane later that same day. They arrived at the Arkansas shelter at three in the afternoon and worked into the night, evaluating one dog after another in an assembly line setup. About halfway through, Sesame was brought in. He was extremely fearful and had a huge abscess on the side of his face from a recent fighting wound that had become infected. He also had a split tongue from unknown trauma. At first, he cowered, but when the women got down on the floor to put him at ease, he cautiously climbed into the assessment volunteer's lap. The women looked at each other with tears in their eyes, moved by this broken little soul who still had love to give. They knew they had to save him.

Sesame was wonderful with people, but his dog evaluation was imperfect—he was not at a point to be safe around other dogs. Not all fighting dogs can recover from dog aggression, but they felt sure that Sesame could.

When they got to the twelfth dog, the trainers stopped for dinner and joined the volunteer vet, the shelter staff, and a board member for a takeout dinner in the small lobby. Most people had to sit on the floor. The behavior consultant saw an opportunity and asked for Sesame to be brought in to meet everyone. She hoped to put a face on the case and help the local rescue connect with the dogs.

The next day, the court awarded full custody of the dogs to the shelter and the effort to get them transferred out began. The dogs ended up being sent to rescues around the country. Sesame was being taken by the evaluator's rescue, but he had tested positive for babesia and heartworm. By law, the babesia had to be treated before he could travel to New England. He was treated in Arkansas, and then just before Christmas 2019, a volunteer flew to Arkansas and drove Sesame north. He was quarantined for five days and then joined his new foster home with the founder of the rescue and her daughter. Sesame stayed with them for a little over a year, during which time he learned basic obedience, worked on his dog skills, and learned how to live in a home as a pet.

Sesame had a lot of applicants, but in the end, a couple who worked from home and had three older kids was chosen. The family had applied only for Sesame and had been waiting patiently. They also lived near the vet who had been treating his babesia. The family had researched dogfighting and babesia and were looking forward to continuing his training and recovery. In February 2021, Sesame went home. He runs up to three miles every day and has his own Facebook page.

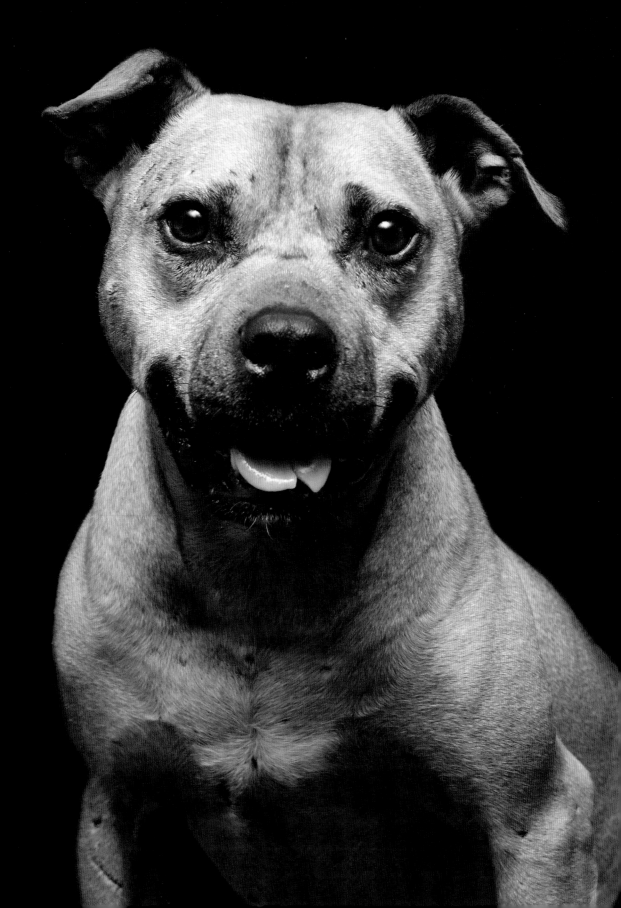

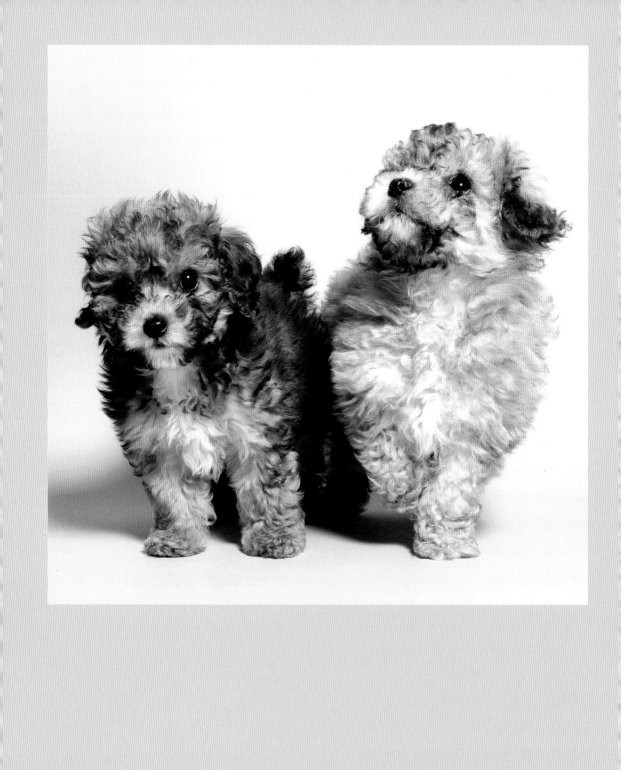

SHREK & GNOCCHI

twelve-week-old male bichon/poodles

In mid-2021, a puppy mill farmer looking to get rid of two bichon/poodle littermates contacted a rescue. When the rescue came to pick up the puppies, the farmer told them that one puppy had a heart murmur and the other had been born without toes. He said he couldn't sell them this way and didn't want to keep paying to feed them if he wasn't going to make any money off of them. If the rescue didn't take them, he was going to put them down.

In puppy mills, humane euthanasia is not used.

The puppies were just five weeks old at the time so the rescue tried to get custody of the mother dog too, but the farmer wouldn't give her up. Since some of the puppies in the litter were still able to be sold, he had decided to breed the mother again. However, the farmer agreed to keep the puppies until they were eight weeks old. (The rescue cannot legally take puppies without the mother before they reach that age.)

The brothers were named Shrek and Gnocchi and were sent to a foster home. Shrek is dark brown and noticeably smaller because of his heart condition. Gnocchi is golden brown. The two are inseparable, always wrestling with each other, play growling, and sleeping on top of one another.

Shrek saw a cardiologist and was found to have patent ductus arteriosus, a congenital heart defect that is defined as a persistent opening between the aorta and the pulmonary artery. The opening usually closes after a newborn puppy takes its first breath, but in Shrek's case it did not. When he was old enough, he had surgery to tie off the shunt. He needed to rest and stay calm during initial recovery, which proved impossible to do with his brother always around wanting to play. Shrek was moved to a quieter foster home for a few weeks but was then reunited with Gnocchi. After a three-month checkup, he will be ready to be adopted.

Gnocchi ended up having a nail grow out of one of his paw pads, which was very painful for him. Eventually his front paw had to be amputated. He is recovering well and, like Shrek, will be available for adoption after a successful three-month checkup.

SISU

age unknown, male Lab/pit mix

Sisu was a stray in the small town of Kenans-ville, North Carolina. Whether he had been dumped or had simply gotten loose, no one knows, but Sisu had clearly lived in a loving home at one point: he was well mannered, knew commands, and bore none of the physical or emotional traits of having lived on the streets for a long time. Someone should have been looking for Sisu, but throughout his very public ordeal, no one ever claimed him.

In March 2021, Sisu started sneaking into the local Dollar General store through the auto-matic door. Once in, he would make a beeline for the stuffed toys at the back of the store and grab a purple stuffed unicorn. He did this at least five times, always running straight for the ten-dollar purple unicorns. Each time, the staff would chase him down and take the unicorn back. Undeterred, Sisu would sneak in again. Eventually someone called the police and animal control came to pick him up. Before he was taken away, the kind animal control officer, who was immediately smitten with Sisu, purchased one of the purple unicorns.

Sisu's story went viral almost immediately. Over the span of a week, he was featured by CNN, *People* magazine, *Today*, and many other media outlets. The small county shelter where he was taken to was suddenly bombarded by

media requests as well as phone calls and emails from people all over the country wanting to adopt Sisu. Completely overwhelmed by the attention, they contacted a lab rescue that they frequently work with and asked if the rescue would take him. The shelter released a state-ment saying that Sisu had an adopter but that he would be receiving some training before going home. They hoped this partial truth would calm things down a bit.

When Sisu was transferred to the care of the lab rescue, they sent him to get neutered and to get all of his vaccines, after which he took up residence at a kennel used by the rescue. This would give the rescue some time to get to know him and assess his unique needs and personality. Throughout, Sisu kept his purple unicorn close. Although other toys were repeatedly offered, he remained loyal to his purple unicorn. Major press outlets who had been following the story now contacted the president of the lab rescue, but he simply told them that Sisu needed to be trained and that he wasn't ready for adoption yet.

Although Sisu would immediately climb up into anyone's lap, he was not good at sharing with other dogs, and the one thing he *really* did not want to share was his unicorn. It was his prize and he guarded it with gusto. The media

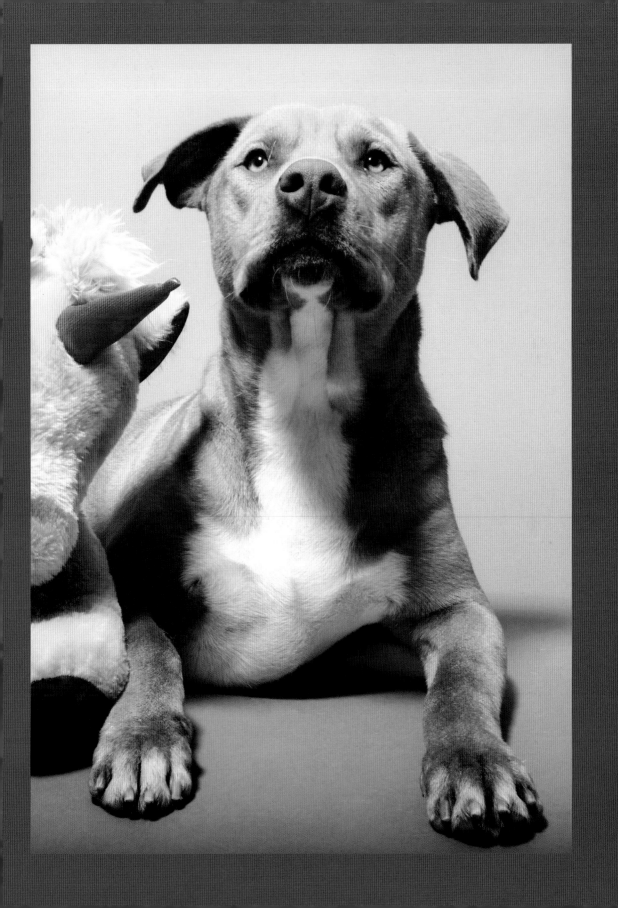

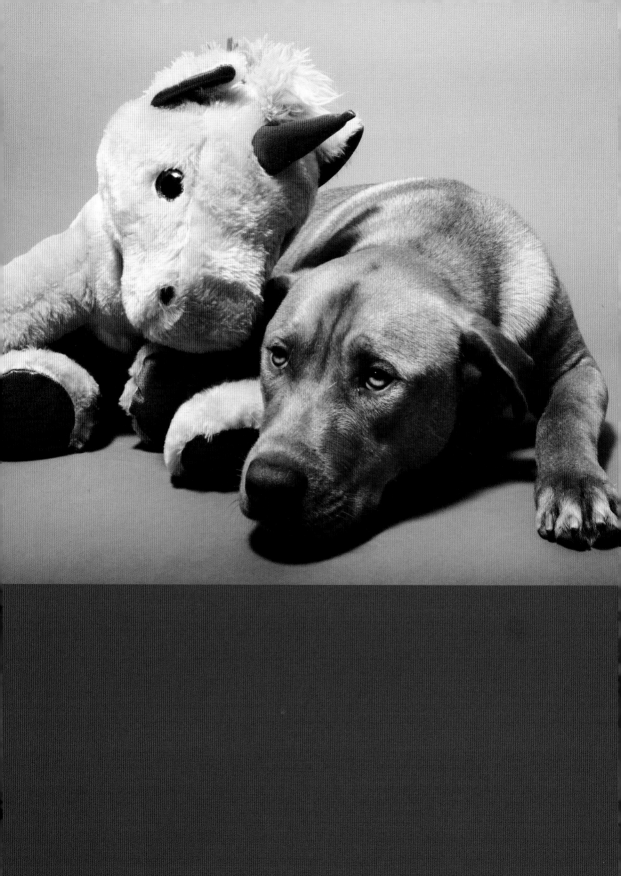

interest soon died off, and after a month of the rescue working with Sisu, he was evaluated. His unicorn guarding had not improved, and they had to make a decision. If he were a dangerous or unpredictable dog, he would need to be euthanized rather than take the chance of placing him in a home where he could injure a person or another dog. Fortunately, they saw what everyone sees in Sisu: a kind, soulful, affectionate dog who adores people. They decided that he just needed more specialized training for the unicorn guarding, so they sent him to board with a wonderful trainer in Virginia.

Sisu has been in residence for over two months and is doing wonderfully. He will be ready for adoption soon, and although all of the previous applications have been discarded, hundreds of people will no doubt clamber to try and get this special dog. Fortunately, only regional applicants will be considered, and each will be screened very carefully. Sisu will need to be the only dog in the home, and he will be fine with that. In a room full of boisterous, playing dogs, Sisu is the one who will curl up in the corner and go to sleep, waiting for his human. Ultimately, as his trainer said, Sisu will choose his person. And, of course, he will go home with a supply of purple unicorns (which

have become hard to find; apparently there has been a shortage at Dollar Generals in the Virginia and North Carolina areas since Sisu's story went viral).

Sisu is an amazing dog. His soul is as deep as the ocean. But what I found most striking about his story is how it reminds us that there is a Sisu in every shelter in every town across the country. Maybe they are not quite as street savvy or lack a proclivity for purple unicorns, but there is a dog who is just as wonderful, just as affectionate, who might never get a chance. Sisu got a chance because he became famous. When his story went viral, he became trackable, noticeable, important. Importance demands accountability. Every single person in Sisu's story was integral in helping him survive and become his best self. Without a kind ACO (animal control officer), a shelter that reached out to a well-funded rescue that agreed to take one more dog—when they already help more than eight hundred dogs a year—and a patient and kind trainer who gave Sisu all the time he needed, Sisu might just have been another number. Overcrowded shelters need resources so they can help more animals. Every one of us can help in some way, whether it is through a donation of money, time, supplies, or expertise.

SLADE

two-year-old male Siberian husky

Slade was born in a puppy mill in Pennsylvania but remained unsold. By eight months old he had become too big for the farmers to sell and was surrendered to a puppy mill rescue group. Slade was immediately diagnosed with two severe congenital cardiac diseases that put him at high risk for sudden death. He had a grade 4.5 heart murmur and a grossly enlarged heart. Puppy mill dogs do not generally receive veterinary care, so the breeders were unaware of his life-threatening condition.

Slade lives as a permanent hospice foster in a home full of dogs that includes three other hospice dogs, one puppy mill survivor who is terrified of people, and three resident dogs. A myriad of foster dogs are continually coming through the house. Slade is the guardian. His foster mom says that he protects the little ones, plays with ones who can play, and lies with the ones who don't have much time left here on earth. He is a kind and nurturing dog who takes care of the hospice dogs, those who are there to die peacefully. When another dog is sick, he will stay by their side till they are back to "normal." Slade is an old soul.

But when Slade first came into his home, they couldn't touch him. He would jerk away and was extremely fearful. Most puppy mill dogs suffer from a lack of socialization, but Slade's behavior was more severe, likely indicating physical abuse. He still only really trusts his mom, who he likes to climb into bed with and "talk" to before they go to sleep. Like most huskies, Slade is very talkative, particularly when he wants attention or is irritated with someone.

Puppy mill dogs who have been raised in inhumane, unnatural settings have to learn basic skills that most dogs grow up knowing, like how to go in and out of a door. Slade learned how to be a dog from the pack he shares a home with. As is often the case, the habits he learned were both good and bad! He is cherished and will live out the rest of his life with his loving family.

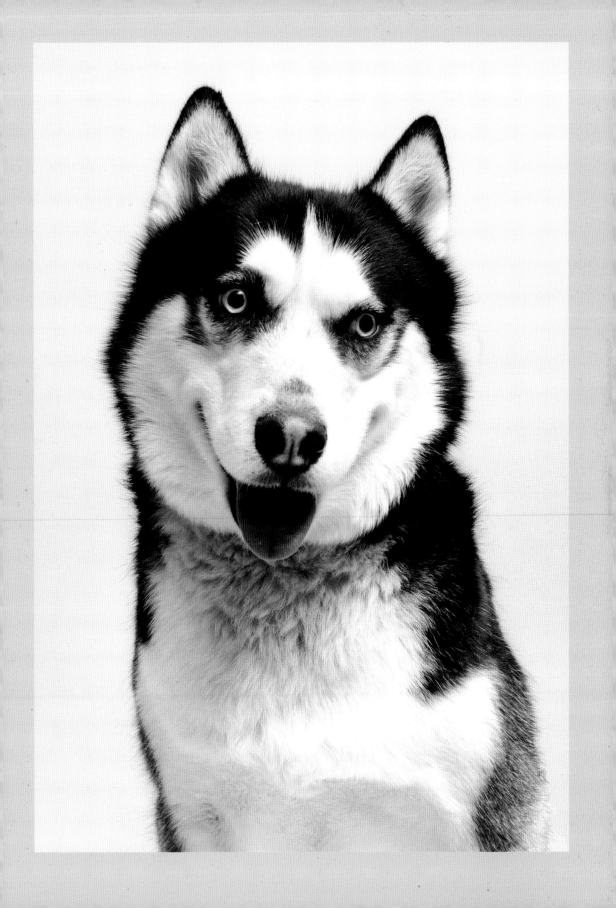

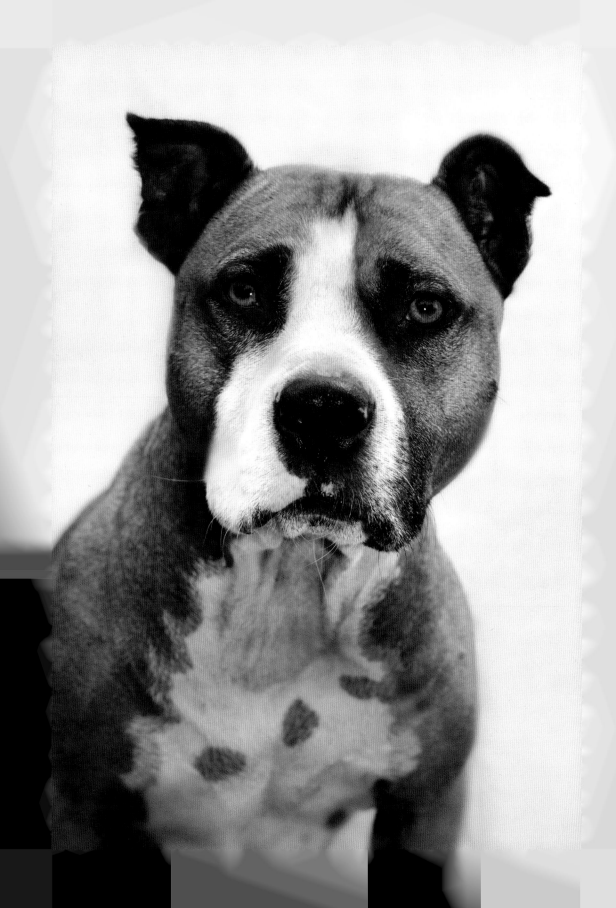

THEODORE

seven-year-old pit bull

Theodore was only eight months old when he was seized as part of the second largest dog-fighting raid in US history. On August 23, 2013, at the request of the US Attorney's Office and the FBI, two national animal welfare organizations assisted in seizing 367 dogs from known dogfighters in Alabama, Mississippi, and Georgia. The dogs were all moved to temporary shelters in undisclosed locations.

Theo was most likely put on a heavy chain at six weeks old. When he was rescued, they found him chained to a barrel on a farm, having never seen anyone but the dogfighter who threw him food periodically. One hundred thirty-five dogs and puppies were seized from this particular man, known as the "godfather" of dogfighting. The dogs were in horrendous condition physically and emotionally, and half of them either died or had to be euthanized.

Theo was held at a temporary shelter while the case slowly moved through the courts. His case was one of the last ones to be resolved, so he and the other remaining dogs were the last to be legally signed over. The dogs were finally released in April 2014 and the dogfighter was sentenced to eight years in prison in November 2014.

Theo spent eight months waiting in a kennel. Although he received enrichment and attention from the volunteers, he did not have the life of a pet. A lead behaviorist who was contracted to work with the 367 dogs ten days a month had been rotating through the hundreds of dogs in the facility for eight months. She didn't meet Theo until the very last rotation, when the behaviorists were getting to know all of the adolescent dogs. She realized almost immediately that he was magical, especially when it came to helping other dogs.

Theo was like instant therapy for dogs with behavioral problems. If he was put with a shy dog, he would help to bring the dog out of its shell; if he was put with a rowdy dog, he would play energetically with them; and if he was put with an aggressive dog, he would do everything possible to defuse the aggression. This pit bull with no socialization was an absolute unicorn.

It is rare for a dog who came from fighting stock to have zero dog aggression and to be so flexible with different canine personalities. If he had remained with the dogfighter, he would have failed as a fighting dog. Fight dogs who lose fights or refuse to fight are often brutally put down.

The behaviorist wanted Theo to have the best possible future, so she called a pit rescue program in New York City and asked if they would accept him. They don't usually take fight bust dogs but said if she personally vouched for this one, they would take him.

The behaviorist's pit bull had died a few years before, and she wanted to adopt an ambassador dog, a pit who would make people want a pit bull. When she put Theo on the truck to go to New York City, she thought, "Aww, that was my dog!!" She kept in touch with his foster home for six days and then decided that she just couldn't let him get away. As soon as she got home to Illinois, she left immediately to retrieve Theo from New York. On the road trip back home, they stopped at a hotel and Theo spent his first night ever in a bed.

Theo turned out to be great with all animals, not just dogs. He hangs out on his mom's farm with horses, chickens, cats, and other animals. He is her constant companion and go-to assistant when socializing puppies or working with shy or reactive dogs.

TITI BANANAS

age unknown, female pit bull

A young female pit bull was seized by animal control officers in 2015 after allegedly biting a social worker who had come onto the property where her owners lived. According to one story, she had been guarding a litter of puppies under the porch of the property when the bite occurred, but no puppies were ever brought in. Other people believed that the entire bite story had been fabricated because the family wanted to be rid of her. No one seemed to know the truth, but either way, Titi was brought to the town shelter, and there she sat.

For four years she lived at the shelter in a kennel, often only getting out to play once a week. Many dogs would have gone kennel crazy or succumbed to severe anxiety or depression, but Titi remained grounded as she waited for a home of her own.

One trainer after another came in and evaluated Titi. Each time, she was determined to be sociable and adoptable, but the city felt that she was too much of a liability to adopt out. However, the shelter workers liked Titi and didn't want to euthanize her, so she became trapped in the shelter system.

After hearing her story, a volunteer trainer who had first met Titi in 2016 went back to the shelter to meet her a year later. She saw Titi's potential and continued to come and visit her. Later in the year, Titi was finally deemed adoptable by the shelter, but the animal control officer wouldn't consider applications from anyone she didn't know personally.

In 2018, someone in town applied and was approved, and Titi went home. She was returned less than two weeks later for resource guarding and high arousal, which means the dog gets easily overexcited and stressed, and shows poor impulse control. These issues were expected by those who knew Titi, but the adopter was unprepared for them. After her return, she was once again deemed unadoptable by the shelter.

The volunteer trainer begged the ACO and the town to let her adopt Titi. Eventually, they agreed but made it clear that no one but her would be allowed to do so. The woman was renovating a house and had to wait until it was completed to bring Titi home, so Titi waited at the shelter for a bit longer. Finally, in September 2019, Titi came to her forever home. Her days are now filled with bird watching, massages, and couch naps. Except for her dinner, she will never have to wait for anything ever again.

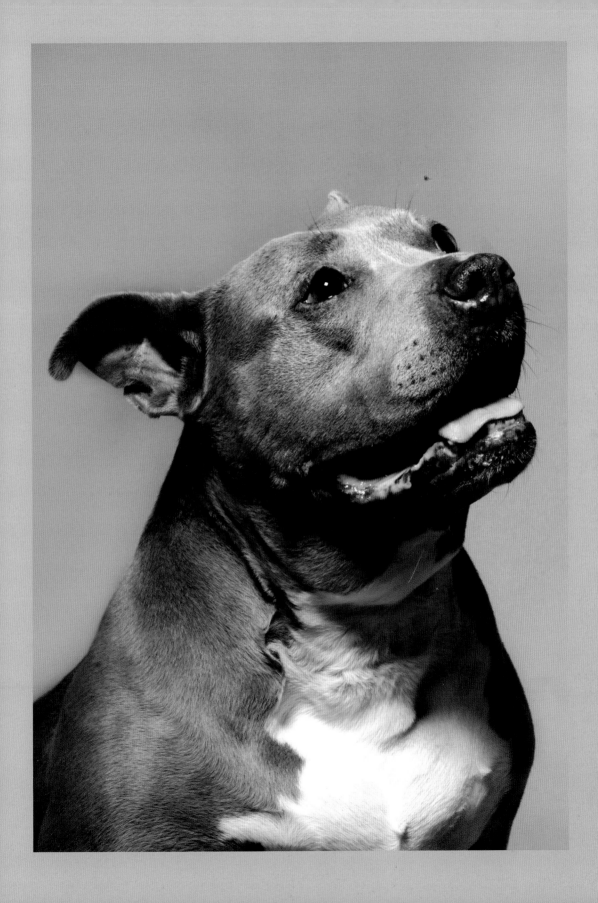

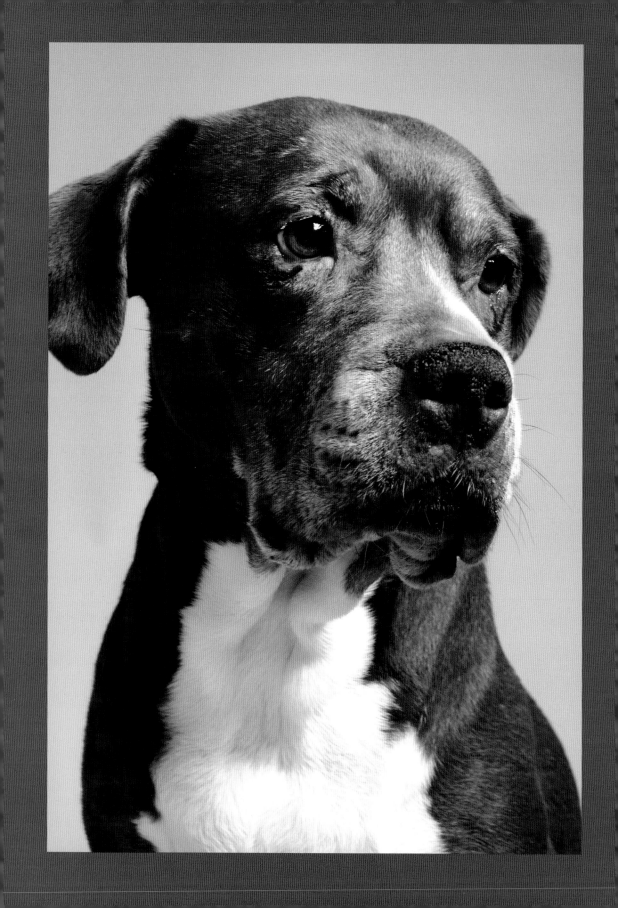

VIVIAN

nine-year-old senior pit bull mix

Vivian was surrendered on a Thursday to a large municipal shelter by a woman who had recently moved to the area from out of state. Vivian (not her original name) had been with her since puppyhood, but the woman was now living with her grandmother, who didn't like dogs. The owner was insistent when she dropped her off that Vivian needed immediate vet care.

Vivian appeared very ill and lethargic at the time of her surrender. Fortunately, the shelter's vet was there doing rounds and immediately examined her. After expedited blood work, it was discovered that Vivian had a glucose level of over 800 (between 150 and 200 is normal). The shelter staff agreed that keeping her over the weekend when the shelter was closed would be inhumane. If they couldn't find a place for her within a few hours, she would have to be euthanized. They had reached out to rescues, but none had gotten back to them. At eight the next morning, the shelter called their most experienced volunteer and asked if she could find an emergency home for a senior Weimaraner mix.

The volunteer instantly agreed to take Vivian home to foster her. With Covid regulations still in effect, she was not allowed in the shelter, so when the staff brought Vivian out, the volunteer thought they had the wrong dog. Vivian was not a Weimaraner of any kind, but a large pit bull mix. She was so lethargic she could barely walk, her eyes were badly infected and painful to open, and she seemed to have skin and ear issues. The foster mom thought that she might only have a few days to live and was prepared to ease her pain and make her comfortable before having to humanely euthanize her.

Vivian was put on insulin that day. The foster mom took her to her personal vet for a full examination (at her own cost) and found that she had a UTI, a double ear infection, a double eye infection, a skin infection, and erratic glucose levels. She was prescribed antibiotics, eye medicine to be administered three times a day, ear medication to be given twice a day, skin meds, and insulin twice daily. To avoid sticking her with a needle multiple times a day to check her glucose level, the vet offered an app-controlled sensor that sends

results directly to the vet, who can then regulate the amount of insulin given.

Within a week, Vivian began showing dramatic improvement. Suddenly she was walking and playing, and her diabetes was under control. She also turned out to be housebroken and well trained. The frequent accidents in her former home were due to the diabetes.

Viv is exceptionally friendly, outgoing, and well behaved. The room for the foster animals has a couch that she loves to lie on. She likes to rearrange the pillows so that she can get maximum air conditioning and rest her head like a human sleeping in a bed. Every time her foster mom comes in to see her, she can hear her tail thumping in excitement before she even sees her. Viv has some masses on her body, which will be removed and biopsied when she gets spayed. If her health remains stable, she will be adopted out, but if it's determined that she needs hospice care, her foster mom will keep her for the rest of her days. She says Viv is a pure joy and is named after Julia Roberts's character in *Pretty Woman* because she's a resilient redhead who "wants the fairytale."

Vivian is an example of a dog who was previously neglected but also very loved. She was not abused, but lack of funds or knowledge or both led to her having a host of untreated life-threatening conditions. Vet care is prohibitively expensive for many animal owners, and clinic options are usually limited to vaccinations and spaying/neutering. So many dogs are surrendered to shelters because their owners are overwhelmed by the veterinary needs of their dogs. It's important to remember that maintenance care along the way can help prevent little problems from blowing up into big ones. Most shelter dogs, if given the chance to heal, will become wonderful companions. Although most shelters don't have the resources for expense treatment, many organizations and individuals have had enormous success with simple online fundraising. People are often very willing to help with a specific animal's vet care. GoFundMe or even just a PayPal link on social media can yield great results.

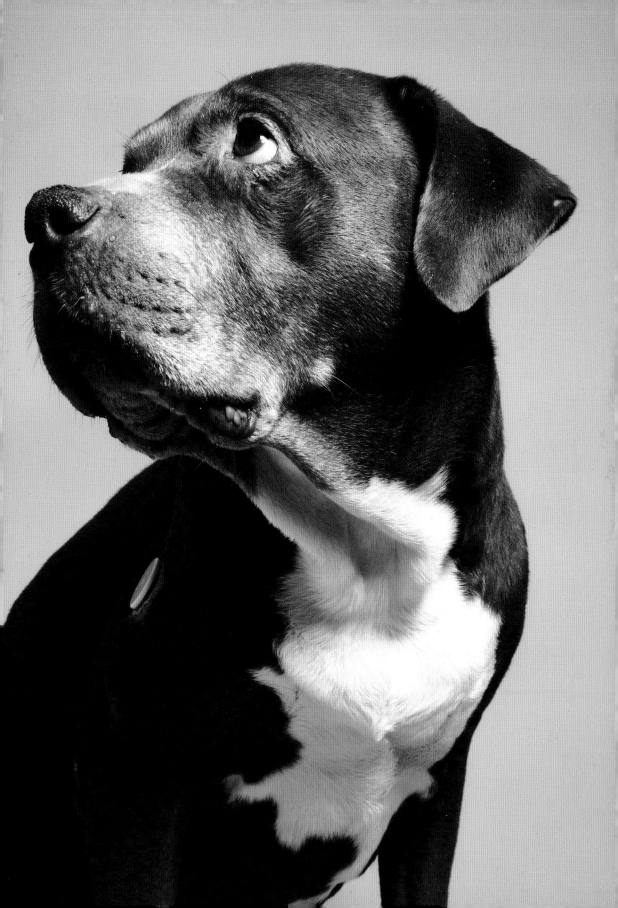

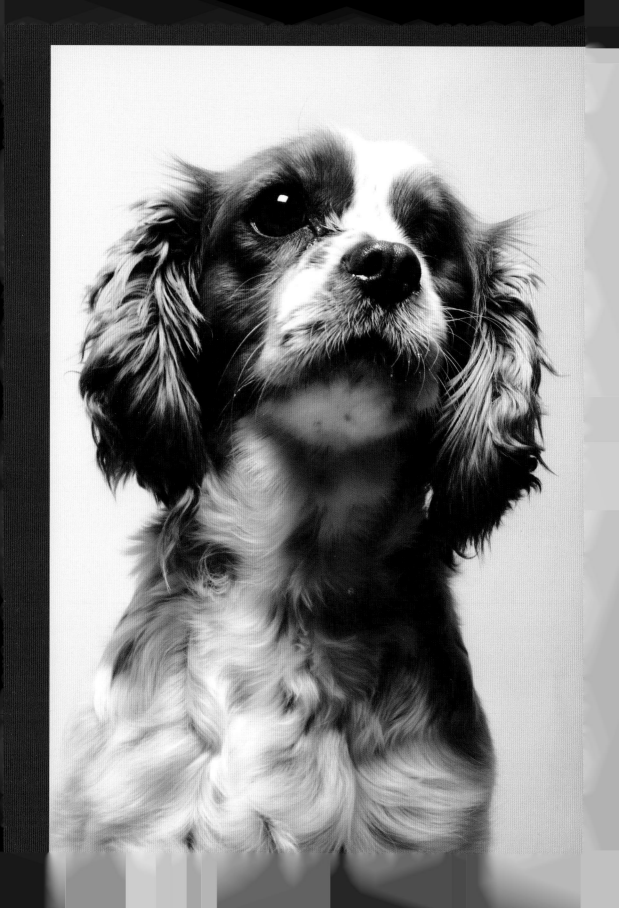

WINNIE

four-year-old female Cavalier King Charles spaniel

Winnie was used as a breeding female in a Pennsylvania puppy mill. She was relinquished to a rescue at four years old after having at least eight litters. When the farmer handed her over to the rescue volunteer, his wife said, "We'll miss her. Her puppies made us a lot of money." Winnie's coat had been shaved down almost to the skin by the farmer, most likely to avoid revealing the squalid state of her fur.

Usually, mill dogs don't receive vet care, but Winnie's eye had been removed and long since healed over, so she must have been given medical attention at some point. The loss of the eye was most likely due to infection or injury, both of which are common in puppy mills. The skin on Winnie's abdomen was extremely stretched out and saggy from having so many litters in a short period. When she was spayed, she was given a bit of a tummy tuck by the vet and is more comfortable now.

Winnie went to a foster home for two weeks, where she could decompress and spend time with other dogs in a normal, healthy setting. Puppy mill dogs generally receive no positive socialization with either dogs or humans and are usually frightened and anxious when they first come into a home. When Winnie went to her adopted home, she was still very timid and would sometimes panic, flattening her whole body on the floor. But even when she "pancaked," as her new family called it, her tail would still be wagging, thumping on the floor. She wanted to be around people—she was just terrified. Soon they nicknamed her "Thumper" because her tail had a mind of its own, even when the rest of her was so scared that she couldn't move.

Winnie had no idea what beds, toys, or grass were. Mill dogs are deprived of the most basic comforts. When placed outside in the grass,

she would lift her feet high like she had stepped in something. When Winnie's family would put out fluffy beds and cozy blankets for her, she would lie on the hard floor beside them, having no idea what they were or that they were a good thing. Winnie watched the family's other dog take toys from the toy basket, but even when she finally did get the courage to go grab one, she just picked it up and then set it down next to her. She didn't know what to do with a toy or what "play" was.

Play is an instinctive behavior in dogs and is present even in very young puppies, but puppy mill dogs live their whole lives in a cage, deprived of toys as well as mobility.

Winnie's family took every new step slowly and patiently. They found great joy in facilitating her transformation and celebrated all of her "firsts": the first time she lay in a bed, the first time she actually played with a toy, the first time she walked on a leash. All of these moments added up and changed her from a terrified puppy mill survivor to a beloved family member.

Cavaliers have become extremely popular in the past few years, which has driven demand way up. Anytime a breed becomes en vogue, responsible hobby breeders suddenly have waiting lists spanning years. People often get sick of waiting and buy from a pet store. Pet store puppies are almost always from puppy mills. Dogs are social animals and among the many cruelties perpetrated by the mills is depriving the dogs of any affection. All dogs suffer in puppy mills, but highly social breeds like Cavaliers suffer horribly from the isolation. Always be sure to buy from a reputable breeder and not a pet store or online. The right dog is worth the wait!

CONCLUSION

Perhaps someday there will be no more unwanted litters, unclaimed lost dogs, or surrendered pets, and all of the kennels will truly be good and empty, but until then, the three million dogs who end up in shelters annually need our help. They need families willing to take a chance on a dog whose journey has been less than linear. Adoption is not always easy, but it's worth sticking it out. With a little patience, love, and support, we can make magic happen: we can help every adoptable dog find their people, their forever home.

Resources

To learn more about the issues mentioned in *Forever Home*, you can use these links as a starting point:

Pet statistics for the United States:
https://www.aspca.org/helping-people-pets/
 shelter-intake-and-surrender/pet-statistics

Puppy mills and backyard breeders:
https://www.humanesociety.org/all-our-fights/
 stopping-puppy-mills
https://www.paws.org/resources/puppy-mills/

Dogfighting:
https://www.aspca.org/investigations-rescue/
 dogfighting/closer-look-dogfighting

Ten ways to help your local shelter or rescue:
https://www.humanesociety.org/resources/
 ten-ways-help-your-local-shelter-or-rescue

Preparing to bring home a new rescue dog:
https://www.petfinder.com/dogs/bringing-a
 -dog-home/tips-for-first-30-days-dog/

Fostering:
https://www.petfinder.com/animal
 -shelters-and-rescues/fostering-dogs/

These organizations shared their time and animals with me and made *Forever Home* possible. Visit their sites and support their amazing work:

A Tail to Tell Puppy Mill Rescue
https://www.atailtotell.com

Delaware Valley Humane Society
https://www.dvhsny.org

Handsome Dan's Rescue
http://www.handsomedansrescue.org

Lab Rescue
https://www.lab-rescue.org

Potter League for Animals
https://www.potterleague.org

Rhode Island Society for the
 Prevention of Cruelty to Animals
https://rispca.com

Saving Grace
https://savinggracenc.org

Acknowledgments

There is a story that keeps people going in the animal rescue world. It serves as a balm when the stings of ignorance, apathy, and burnout take their toll, and it reminds us that what we do matters. It's called the starfish story:

> One sunny morning after a violent storm, a man was walking on the beach. In the distance, he saw a small figure dancing on the sand. As he got closer, he realized that it was a young girl picking up starfish that had washed ashore and lovingly throwing them back into the sea. He asked her why she was doing that, to which she said, "The tide is going out now; if I don't throw them back into the ocean they will all die." The man paused, looked down the beach, and said, "But surely you can see that there are miles and miles of beaches and thousands of starfish. You cannot possibly make a difference." The girl listened, then bent down, picked up another starfish, and gently tossed it back into the water. She smiled at the man and said, "It made a difference for that one."
> —adapted from "The Star Thrower" by Loren Eiseley

So many foster parents, shelter staff, trainers, and volunteers selflessly gave their time to help me make this book. Because of the work that they quietly do every day, thousands of starfish have been thrown back in the sea, and it has made all the difference.

There would have been no book without Trisha Torres and Katenna Jones, who helped me conceptualize *Forever Home* from day one. You helped me connect the dots in dozens of ways to form a beautiful path. Massive gratitude also to Bethany Nassef, who has worked with me over the span of many years and several books. You always make time for me and give me access to so many wonderful dogs.

To my agent, mentor, and friend Joan Brookbank, who took a chance on *Shelter Dogs* almost twenty years ago and has been with me for every single book I have ever done: I would be lost without you. Truly.

I am deeply indebted to all of the rescues that worked with me to make *Forever Home*: Potter League for Animals, A Tail to Tell Puppy Mill Rescue, Rhode Island SPCA, Handsome Dan's Rescue,

Lab Rescue LRCP, Delaware Valley Humane Society, Saving Grace, and Perry County Animal Rescue.

And most of all, thanks to the volunteers, trainers, foster parents, and staff who made time for my visits, wrangled during photo shoots, and answered endless follow-up questions: Jill Ashley, Jacqueline Baffoni, Amanda Fansler-DeLuca, Heather Gutshall, Erin Insinga, Kris Jewell, Kara Montalbano, Cindy Myers, Sarah Neiswender, James Oliver, Susan Owenby, Rianna Ramirez, Stephanie Schwartz, Sterrie Weaver, and Megan Yaffe.

Thank you to Trish McMillan for hosting me in the magnificent North Carolina mountains and to Mary Shannon Johnstone for moving mountains!

To my ladies at Princeton Architectural Press: Sara Stemen and Jennifer Thompson, I am so grateful for the opportunity to make beautiful and meaningful books with you. Many thanks to Paul Wagner and Natalie Snodgrass at PAP for the stunning book design.

Finally, to my Jesse and Agatha, who are always supportive of my work, even when it is inconvenient.

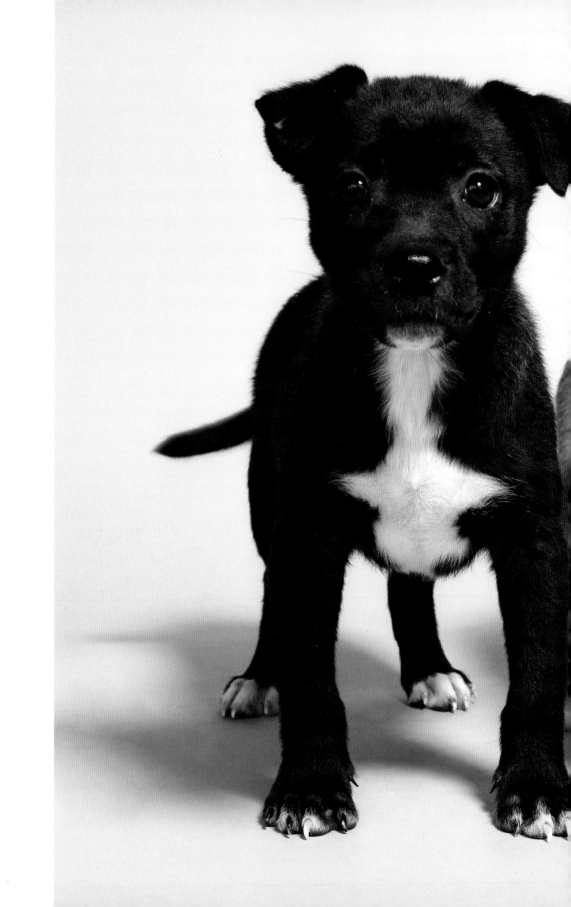

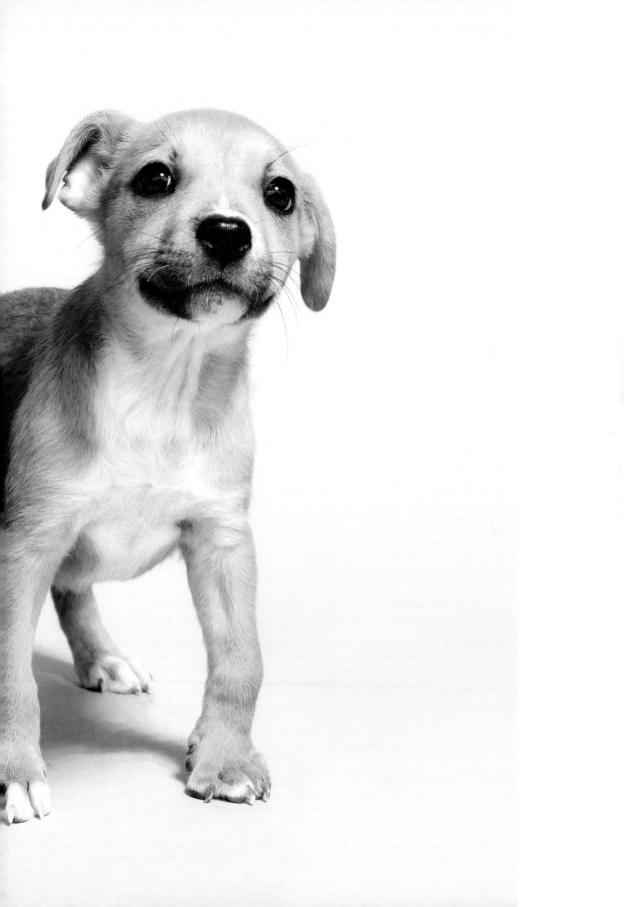

Published by
Princeton Architectural Press
70 West 36th Street
New York, NY 10018
www.papress.com

Editors: Jennifer Thompson and Sara Stemen
Designers: Paul Wagner and Natalie Snodgrass

Library of Congress Cataloging-in-Publication Data
Names: Scott, Traer, author.
Title: Forever home : the inspiring tales of rescue dogs / Traer Scott.
Description: First edition. | New York : Princeton Architectural Press,
 [2022] | Summary: "Photographs of rescue dogs and their heartwarming and
 inspirational stories—a celebration of pet rescue and adoption in all
 its forms"—Provided by publisher.
Identifiers: LCCN 2021042813 | ISBN 9781648960697 (hardcover)
Subjects: LCSH: Dogs—Pictorial works. | Dog rescue—Anecdotes. | Dog
 adoption—Anecdotes.
Classification: LCC SF430 .S3835 2022 | DDC 636.70092/2—dc23
LC record available at https://lccn.loc.gov/2021042813